IMAGES of America
DeFuniak Springs

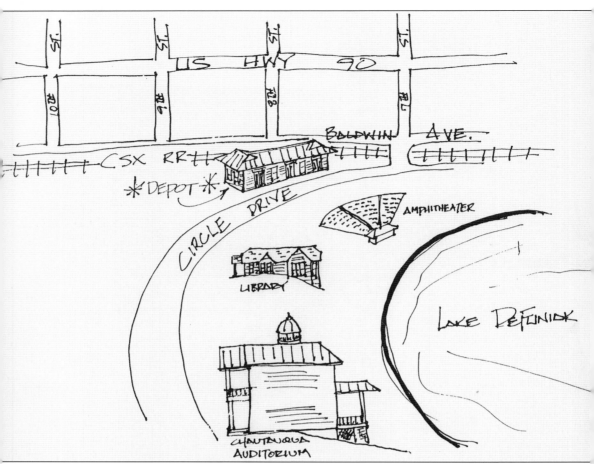

This hand-drawn map was included with the Historic Preservation Grants-in-Aid Application submitted to the State of Florida for the restoration of the former train depot, which is owned by the City of DeFuniak Springs. The building was restored in the 1990s and has served as the home of the Walton County Heritage Museum since July 4, 2002.

ON THE COVER: This photograph of the Florida State Normal School was printed from a glass plate made by G. Willard Shear, who advertised himself as the "Artist for Pensacola & Atlantic Railroad Co." The glass plate was one of 16 discovered under the floor of the building that once housed the photographic studio of T. Hope Cawthon, another prominent photographer. The building was dismantled many years ago, and Glenn Parker, a member of the demolition crew, had the foresight to save the plates rather than dispose of them. Dianna Van Horn and her father spent many hours cleaning the plates, and she was able to develop photographs from them. (Courtesy of Walton County Heritage Association.)

Images of America

DeFuniak Springs

Diane Merkel on behalf of
the Walton County Heritage Association

Copyright © 2008 by Diane Merkel
ISBN 978-0-7385-5407-5

Published by Arcadia Publishing
Charleston SC, Chicago IL, Portsmouth NH, San Francisco CA

Printed in the United States of America

Library of Congress Catalog Card Number: 2008920660

For all general information contact Arcadia Publishing at:
Telephone 843-853-2070
Fax 843-853-0044
E-mail sales@arcadiapublishing.com
For customer service and orders:
Toll-Free 1-888-313-2665

Visit us on the Internet at www.arcadiapublishing.com

*To the people of DeFuniak Springs, past and present,
and to all who helped establish and have supported
the Walton County Heritage Museum.*

Contents

Acknowledgments		6
Introduction		7
1.	Lake DeFuniak	9
2.	Railroad Ties	13
3.	Florida Chautauqua	21
4.	Colleges and Schools	33
5.	Agriculture	47
6.	Businesses	59
7.	Homes	85
8.	Hotels	101
9.	Churches	111
10.	Community	117
Bibliography		126
Index		127

ACKNOWLEDGMENTS

The photographs and documents presented in this book are from the permanent collection of the Walton County Heritage Association unless noted otherwise. Some individuals contributed materials from their personal collections and deserve public thanks and recognition, namely David Bludworth, Annie Ruth Campbell, Perry Correll, John D. Courtney, Frankie Healy, Marie Hinson, Charles King, Voncille and Roy McLeod, Rose Rogers, Bill Steadley-Campbell, Lou Taylor, Ann Williams, Wayne Wirth, and Sonny Yates. Carol and Elmer Williams of the Williams Gallery have been exceptional friends of the Walton County Heritage Association. Many more people offered much appreciated moral support, and I regret I cannot list them all due to space limitations.

Special thanks must go to two people: Jeanette Anderson McDonald and Scott Clary. Jeanette has collected articles and photographs of DeFuniak Springs for many years and is always willing to share her knowledge, and Scott gave me unlimited access to his extensive collection of photographs and postcards. I also give thanks to my mother, Irene E. Davis, and my husband, Charles E. Merkel Jr., for their unconditional love and support. Finally, this book would not have been possible without the help of the staff of Arcadia Publishing, especially my editor, Luke Cunningham.

My role in this project was similar to that of a quilter, piecing together a patchwork of the history of the city in photographs. By its nature, this book is not the definitive history of DeFuniak Springs, and it does not represent every family who has lived here or every home that has heard laughter. It will be a success if those who visit DeFuniak Springs through these pages want to learn more about this great little city or if the families represented herein find pleasure in their inclusion.

If you enjoy this book, I hope you will be inspired to share your photographs, stories, and memorabilia with the Walton County Heritage Association and its museum so that future generations can fall in love with the history of DeFuniak Springs just as we have.

—Diane Davis Merkel
Trustee, Walton County Heritage Museum

INTRODUCTION

The "open pond" that is now known as Lake DeFuniak was discovered by a railroad survey party in the summer of 1881. The three men of the party, Col. William D. Chipley, Maj. William J. Van Kirk, and Thomas T. Wright, decided a town should be built around it. With the railroad came civilization and the first known photographs of the city. G. Willard Shear of nearby Sneads was employed by the Pensacola and Atlantic Railroad in 1885 to record "Illustrations of West Florida." The Walton County Heritage Association owns many of those original images, some of which are reproduced for the first time in this book.

Second only to the railroad, the Chautauqua movement was responsible for much of the growth and development of DeFuniak Springs. The movement started in August 1874, when the Sunday School Normal Assembly of the Methodist Church opened with a two-week series of lectures on the shores of Lake Chautauqua in New York. Sunday schools across the country taught basic literacy at the time, and the assembly offered teachers an opportunity to broaden their knowledge. In February 1885, the first Florida Chautauqua convened on the shores of Lake DeFuniak. Chautauqua brought visitors by the trainload, so hotels and businesses were built to accommodate them. Most of those buildings are gone now or serving other purposes, but many are preserved in photographs.

The postal service had first designated the town as "Funiak" in 1882. Several visiting professors attending the first Florida Chautauqua discovered the source of the lake was a spring and, by early 1886, the name of the town was changed to DeFuniak Springs to promote its healthy aspects for both mind and body.

In 1893, Wallace A. Bruce became the president of the Florida Chautauqua. Music and entertainment had always had roles in the assemblies, but now singers, instrumentalists, bands, orchestras, and operettas were as popular as the lectures and lessons. One account reported that the Smith brothers, most likely William Wallace Smith II and Robert Lansing Smith, would arrive early before concerts and place free boxes of their cough drops on the benches.

The Chautauqua assembly brought other educational opportunities to the new city. In 1886, due to the efforts of William D. Chipley, the Florida Chautauqua hosted the first statewide teacher's institute, which the railroad assisted by giving special fares for teachers and school administrators. That was the first meeting of what was to become the Florida Education Association. The State Normal School was founded in 1887 and was the only school in Florida devoted exclusively to the preparation of teachers. In 1904, it moved to Tallahassee, the state capital, and became a part of the Florida State College for Women, which is now Florida State University. Palmer College (1907–1936) is considered to have been the first junior college in Florida, and the Thomas Industrial Institute, which was built as a memorial to Hiram Thomas by his wife, served students from 1913 until 1924.

The year 1898 was particularly difficult for DeFuniak Springs. The town experienced an unusual snowstorm in the winter and a large fire in September. Many of the buildings in the principal business district were destroyed, but the industrious businessmen soon replaced those wooden structures with brick buildings, many of which still survive today.

Property owners decided to incorporate the city in 1901, and the first public water works system was installed in 1907. On January 1, 1910, a jubilant witness wrote to a friend in California, "Happy New Year! The electric lights were turned on last night!" While the city was growing, many of its citizens remained rooted to agriculture. Timber industries were natural choices for businesses because of the county's thickly forested acreage, but poultry and dairy farms were numerous also.

World War I brought a decline in Chautauqua attendance from which it never recovered, and the Great Depression led to the closure of Palmer College as well as many businesses. Nevertheless, when World War II was declared, the people of DeFuniak Springs did not hesitate to respond. They sent their sons and daughters into service and sacrificed for the war effort without question. Many of the children of those days are retired now and have returned to DeFuniak Springs after decades in other cities. They are home again.

Through the decades, the people of DeFuniak Springs have honored their past by preserving it. The circle around Lake DeFuniak, first known as Wright Avenue, is the focal point of the Historic District of DeFuniak Springs. Almost 200 beautiful homes grace the district and are in the National Register of Historic Places thanks to the efforts of the Walton County Heritage Association. The Chautauqua Hall of Brotherhood and St. Agatha's Episcopal Church have recently been restored. The Florida Chautauqua has been revived, and the Walton County History Fair is always a success with all age groups. There is no doubt that, in the decades to come, the people of DeFuniak Springs will continue to honor their heritage.

One
LAKE DEFUNIAK

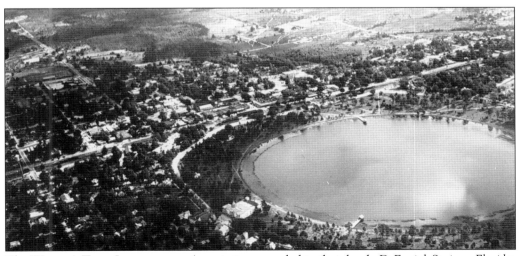

The Woman's Town Improvement Association recorded in their book, *DeFuniak Springs, Florida, 1906–1907*: "Indian Legend of the Spring: The Great Spirit was enraptured with the beauties of this hill, and bending down from heaven, imprinted a kiss thereupon which left a dimple, afterwards filling it with the nectar that was to answer for all generations as a healing remedy for His people." (Courtesy of Scott Clary.)

The lake is approximately 250 feet above sea level at one of the highest points in Florida. It measures nearly a mile in circumference and is over 60 feet deep. It is said to be one of two naturally round lakes in the world, the other in Switzerland. It has been a place of legend and lore since its discovery by Native Americans. When DeFuniak Springs was founded in the early 1880s, spas and minerals springs were popular throughout the country, so the potential healing powers of Lake DeFuniak were often used to entice visitors. Some scientists who attended the first Florida Chautauqua proclaimed there were special medicinal attributes of the water. An 1892 article stated, "The waters of the lake (really a spring) are exceedingly beneficial in case of kidney and similar diseases."

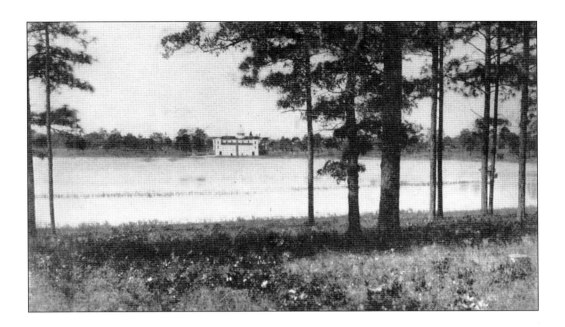

Postcards often mentioned the lake. In March 1920, a woman wrote to her friend in Baltimore: "This lake is said to be as round as a silver dollar and the town is built around the lake." A mother wrote to her children, describing her impressions of DeFuniak Springs: "It is a great winter resort & I like it better than any town I have seen for a long time. . . . There are no creeks running into this lake. No one seems to know where the water comes from." In February 1921, a man wrote to his son in Arkansas: "Fine here. 60° outside on lake. No snow. I'm waiting for you down here in the land of sun and sand, where fish, game, alligators, & ostriches abound." (Courtesy of Scott Clary.)

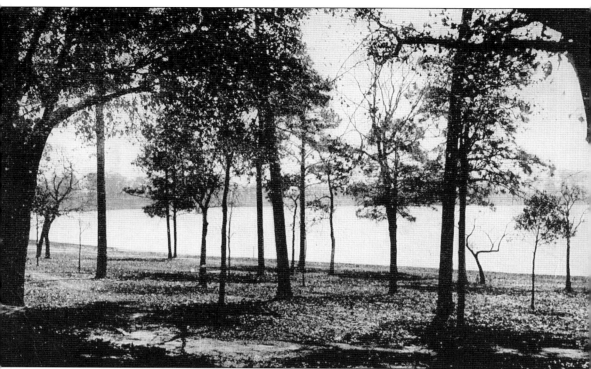

Photographs of the lake were often used to represent DeFuniak Springs. This photograph appeared in R. E. L. McCaskill Company's 1920 promotional booklet *The Road to Health, Happiness, and Prosperity* with the caption "This lake, one mile in circumference, nearly a perfect circle, and teeming with fish, forms the center around which DeFuniak Springs is built. It is fed by living springs." Raymond G. Wickersham, whose family lived on Main Street, used a postcard of this photograph to send a note to his lieutenant at Camp Jackson, South Carolina, in August 1921. "Just a word from one of your C. M. S. C. boys in Company 'A.' Just as you said we were all anxious to get to our homes but are beginning to miss the camp activities and the associations. You can rest assured that all of us appreciated your command." (Courtesy of Scott Clary.)

Two

Railroad Ties

In March 1881, the Pensacola and Atlantic Railroad was chartered by the Florida legislature to construct a track from Pensacola to Chattahoochee. The company received financial backing from the Louisville and Nashville Railroad to construct the 170-mile track, which was completed in 1883. The Pensacola and Atlantic ceased operations as an independent line in July 1885, when it was fully incorporated into the Louisville and Nashville system. An item in the 1892 Florida Chautauqua quarterly stated, "The Louisville and Nashville R. R. is one of the best managed roads in America. There is not as much noise made about it as about some others but it gets there just the same." Over the next eight decades, passenger service declined. In 1971, the Louisville and Nashville Railroad became a subsidiary of Seaboard Coastline Railroad, and the last train stopped at DeFuniak Springs that April. The Louisville and Nashville merged into Seaboard in 1982 and, in 1986, Seaboard and the Chessie System merged to form CSX Transportation, the current line that runs freight trains through DeFuniak Springs. (Author's collection.)

Legend has it that Frederick de Funiak, left, who immigrated from Europe in 1861, won the right to name the town in a card game. The *New York Times* published his death notice in March 1905: "Col. Frederick De Funiak died at his residence here today. Col. De Funiak was born in Rome, Italy, sixty-five years ago, and was a veteran of Garibaldi's army. He was for a long time chief engineer of the Louisville and Nashville Railroad, and has been connected with the railroad building in many parts of the country." Two of his sons followed his footsteps albeit on different paths. Frederick Jr. had a distinguished career in the U.S. Army, and Ernest, pictured below, was the freight traffic manager for the Louisville and Nashville Railroad in Birmingham from 1904 until 1918.

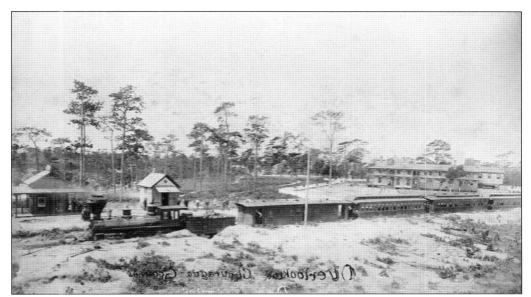

At the end of the 19th century, the railroad was the lifeblood of DeFuniak Springs, bringing visitors and commerce to the new town. This 1885 photograph is the earliest known of the first train station in DeFuniak Springs. The smaller building has a sign saying "DeFuniak Springs" above its door. The Hotel Chautauqua is in the background on the right.

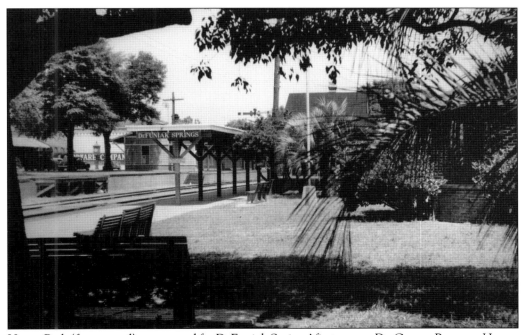

Henry Park (foreground) was named for DeFuniak Springs' first mayor, Dr. George Pomeroy Henry. During the Chautauqua assemblies, bands would meet incoming trains at Henry Park and greet them with an outdoor concert. The first train depot was replaced with a new one in 1889, and alterations were made in 1910 and 1911.

Railroading was hard work, often requiring backbreaking labor on the track. The two men on the left above are unidentified, but the other workers in this 1929 photograph are, from left to right, Alex B. Powell (age 17), George Powell, and Horace Brooks. In the photograph below, which is probably from the same time, the sixth man from the left is Charlie Stevens of Bonifay, the uncle of Mabel Paul McLeod.

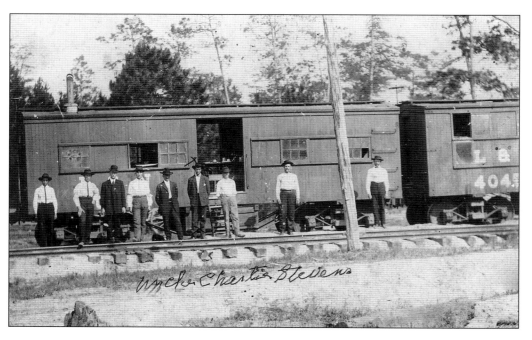

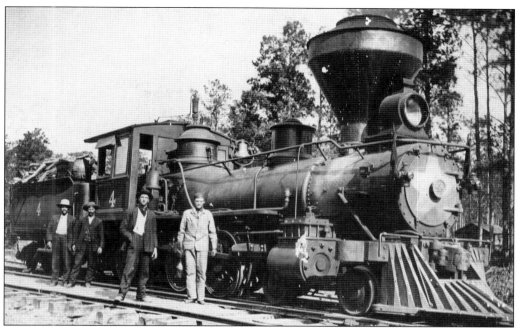

Engine No. 4 was equipped with a cabbage-style spark arrester on its stack. Such "cabbage stacks" were crucial equipment in timber regions, where an errant ember could start a forest fire. The pilot on its front, also known as a cowcatcher, was used to nudge objects and animals away from the train. (Courtesy of Charles King.)

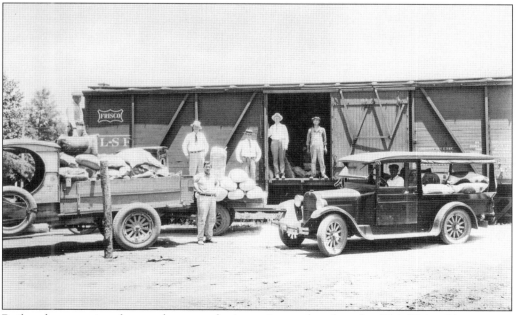

Railroad companies often used one another's cars just as they do today. This "Frisco" boxcar was the property of the St. Louis–San Francisco Railway Company. The feedbags being off-loaded often served a dual purpose in the rural communities. After being emptied, the most attractive of them became someone's new shirt or skirt. (Courtesy of Charles King.)

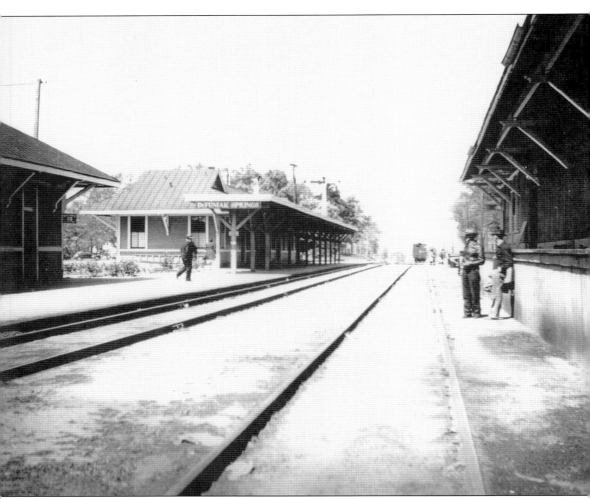

This view of the tracks shows all three of the buildings that comprised the DeFuniak Springs railroad stop. On the far left, the Railway Express building handled small cargo shipments. The passenger depot is shown with its shed extending beyond the building boundaries. The freight depot on the right handled large commercial shipments, such as livestock or barrels of resin.

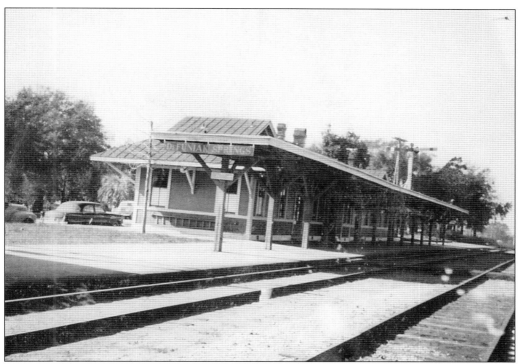

The covered walkway was called the train shed and provided passengers protection from rain and the hot Florida sunshine. (Courtesy of Scott Clary.)

In 1946, Wayne Wirth, pictured above, visited DeFuniak Springs with his family, who rented a home here. His family had been coming here regularly, starting in the 1890s, to attend Chautauqua. The photograph was taken from the corner of the passenger depot looking east toward the Railway Express building, which was where the caboose now sits. (Courtesy of Wayne Wirth.)

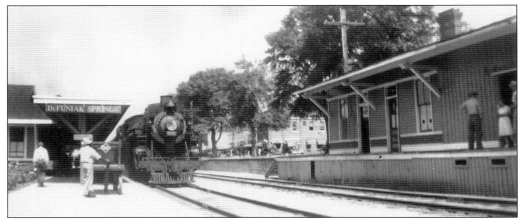

This is a good view of the railroad station in action in the 1940s. The passenger depot (left) will soon receive passengers, so the baggage cart is being pushed into position. The train is arriving, and people are watching it from the freight depot. (Courtesy of Wayne Wirth.)

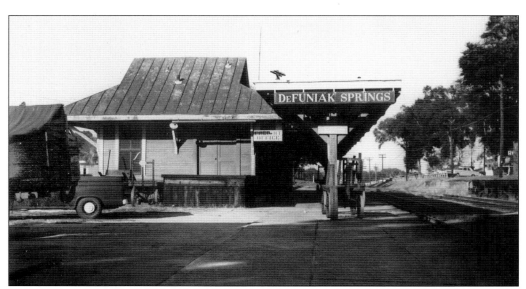

This view of the passenger depot, probably during the 1960s, shows that a freight office and dock have been added to the east end of the station because both the freight depot and the Railway Express buildings are gone. One of the Railway Express baggage carts sitting under the train shed is now owned by the Walton County Heritage Association.

Three
FLORIDA CHAUTAUQUA

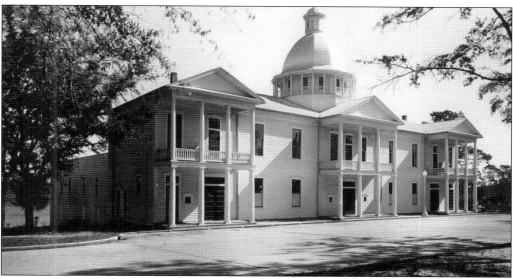

The *Breeze*'s Women's Club edition reported in 1929, "DeFuniak Springs enjoys the distinction of a town built about an idea. Hence, its early history and that of the Florida Chautauqua are one, and its action is but thought materialized. Their common origin may be traced back to a summer night in 1881, when three members of a surveying party, seeking a route for the projected railroad across the State, lay down on a grassy slope surrounding the little lake, which has since been poetically described as 'God's crowning circle wrought with compass true'. Under the magic of the time and place, the men fell to dreaming and each translated into speech the vision he found within him. . . . Arrangements were duly consummated for the first assembly, to be held, February 10th to March 7th, 1885. The announcement attracted instant attention, the very name 'Chautauqua' challenging inquiry, but the dictionary gave no clue, for 'Chautauqua' is the designation of an idea; the crowning idea of the Nineteenth Century." (Courtesy of Scott Clary.)

In August 1884, the *Florida Times-Union* of Jacksonville reported, "Dr. A. H. Gillet with a party are touring in Florida looking out for a suitable locality for a winter Chautauqua and will return to Jacksonville on the 12th inst." Charles C. Banfill saw that notice while attending a conference in Jacksonville and contacted Gillet, inviting him to see the small town. John L. McKinnon, in *History of Walton County*, described the events that followed: "Dr. Gillet and Rev. C. C. McLean returned with him. It rained and poured for several days. . . . They looked over the grounds between showers and held an interview with the land owners and were very much pleased with the situation and prospects ahead. So, in a little while all the arrangements were consummated for the Florida Winter Chautauqua to have its home here." Rev. Dr. August H. Gillet (above) became the first superintendent of instruction of the Florida Chautauqua and retained that position until his death in 1893. (Courtesy of Jeanette Anderson McDonald.)

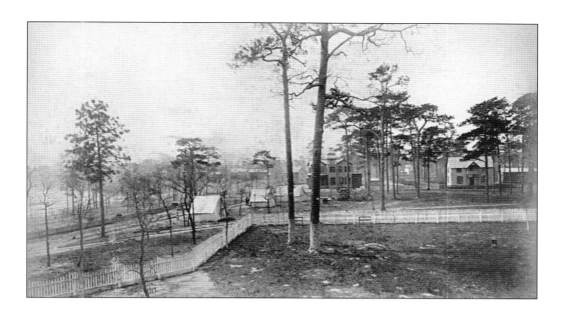

The first session of the Florida Chautauqua convened on February 10, 1885, and lasted until March 9. Classes met during the day, and various types of entertainment were featured at night. A few buildings had been constructed, but tents along the shore of Lake DeFuniak provided much-needed additional space for the attendees. One of the speakers at both the 1885 and 1886 sessions was Wallace Bruce, who would later assume a significant role with the Florida Chautauqua. These G. Willard Shear photographs, probably from 1887, show the views looking towards the lake from the Hotel Chautauqua (above) and the attendees by the lake.

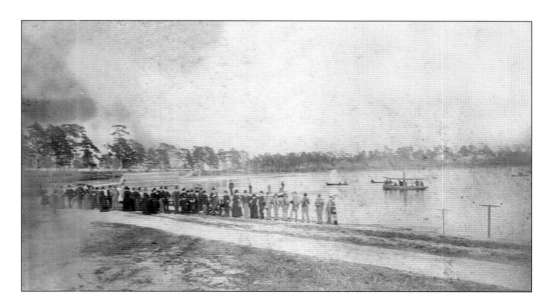

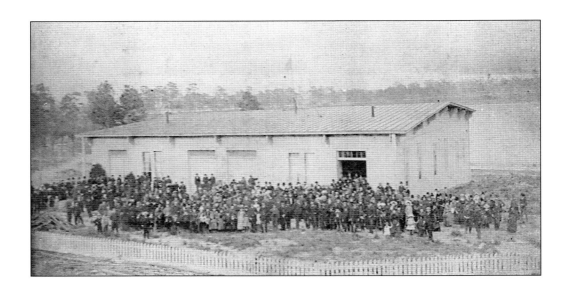

For the 1887 session, a large auditorium called the Tabernacle had been built. These G. Willard Shear photographs show the closing day of the Florida Chautauqua in March 1887. The New York Chautauqua published journals of articles and news of the various Chautauqua assemblies across the country. In DeFuniak Springs, the first *Florida Chautauqua* quarterly newsletter (opposite, top) was published in June 1892 and featured the photograph above on the front page.

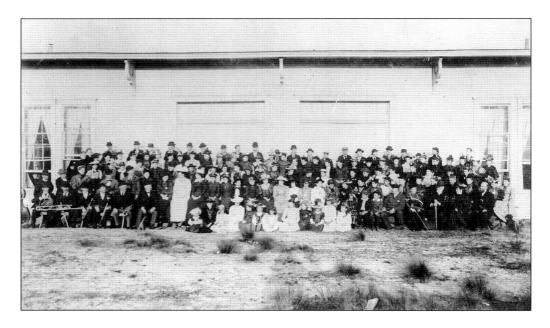

The Florida Chautauqua.

Vol. 1. DeFUNIAK SPRINGS, FLORIDA, JUNE, 1892. No. 1.

The Woods on a Summer Morning.

Have you heard, of a summer morning,
 The burst of the woodland praise,
Like the glorious hallelujah
 Which God's people love to raise
In their churches and cathedrals,—
 "He reigneth forevermore?"
It is the most sublime in the woodland
 When the winds through the tall trees roar.

"He liveth forever and ever!"
 It sounds from the crested hills,
It echoes in sheltered valleys,
 And is sung by the tinkling rills.
The pines take it up in a whisper,
 And the ferns repeat it again—
"He liveth forever and ever!"
 In an endless, soft refrain.

The breeze tones down to a zephyr,
 And the birds pour forth their lays,
And oh, what a burst of music
 From their golden throats they raise—
"We praise Him for tender mercy,
 We praise Him for loving care!"
And the winds take up the anthem,
 Till the charm is everywhere.
 —[Anna Preston.

find homes here and to seek fame, wealth or renewed youth in this Land of Flowers. Even stories of trembling old Ponce deLeon, seeking the peerless fountain, and the mail-clad DeSoto marching westward toward the great river.

Wonderful pines are these of De-Funiak Springs, and wonderful the gleaming fountain they encircle. But more than air and sun and pines and glistening lake, are friends. Every turn of the car wheel bore us from those who, in a time of pain and trial, proved themselves friends.

Three days in Pensacola—guests of Mrs. W. D. Chipley, than whom in all this hospitable southland none know better the art of making the guest at home; there were pleasant drives, interviews with friends and begin the ascent of thirteen miles, which is to bring you to the assembly gates. Up, up, the little puffing engine, with his load of three cars goes. Though No. 99 makes a good deal of noise, it is not like the Coosa River steamboat of which Sam Jones tells, which must needs stop its paddle wheels when it whistles because it has not enough of steam for noise and business too. Our engine never allows its foot to slip, though grades are steep and curves are short, and brings us at 11:43 a. m. to Mont Eagle Station. Here we are at the summit of the Cumberland mountains, 2200 feet above sea level, and 1500 feet above the valley below. Here on the crest is a plateau eighteen miles in length and five in width, with cultivated fields, farms, of rock down into the road below, so completely blockading it that it has never been opened and likely never will be.

In another direction there's "Fairmount Falls" and Forest Point. Two and a half miles east—a pleasant morning tramp, which even an invalid may undertake in this bracing air—is a wild canyon down which leaps a mountain stream, and where the wall of the canyon breaks, goes over the precipice in a fleecy lace-like sheet which is named Bridal Veil Falls.

Alpine View invites the pedestrian another way; and then there are the caves, and the roads down the mountain with glimpses of beautiful and picturesque ravines, rushing mountain streams in the clear pools of

The 1893 program (right) listed A. H. Gillet as the superintendent, but page three bore the news of his death. "It is with utmost sorrow we announce that Dr. Gillet, soon after completing our program for the coming session, passed from labor, to rest and reward, at De Funiak January 1, 1893. 'The destruction that wasteth at noonday' had for a year made unceasing progress. All remedies seemed vain, but the manly struggle against the inevitable went on through the year. He was hopeful and cheerful, putting into exercise all the evincing resources at command. His work was done, however, and so earnestly and abundantly had he labored that he reached rest all too soon."

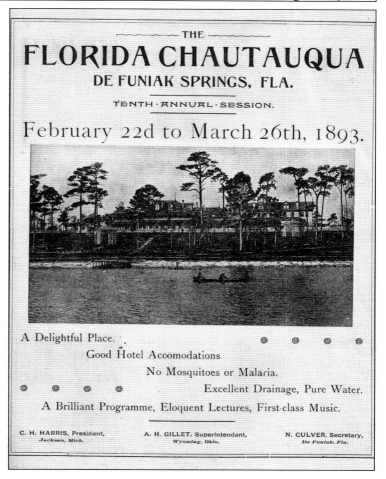

THE
FLORIDA CHAUTAUQUA
DE FUNIAK SPRINGS, FLA.
TENTH · ANNUAL · SESSION.

February 22d to March 26th, 1893.

A Delightful Place.

Good Hotel Accomodations.

No Mosquitoes or Malaria.

Excellent Drainage, Pure Water.

A Brilliant Programme, Eloquent Lectures, First-class Music.

C. H. HARRIS, President, A. H. GILLET. Superintendant, N. CULVER, Secretary,
Jackson, Mich. Wyoming, Ohio. De Funiak, Fla.

This T. Hope Cawthon photograph gives a view of the Chautauqua Hall of Brotherhood on the left with the First Methodist Church visible across the street. The Hotel Chautauqua is the long structure in the middle of the view, and the train depot is directly across the lake from the man.

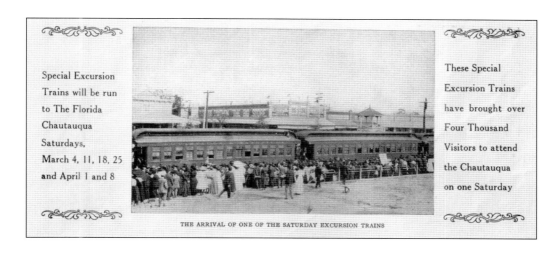

Special Excursion Trains will be run to The Florida Chautauqua Saturdays, March 4, 11, 18, 25 and April 1 and 8

These Special Excursion Trains have brought over Four Thousand Visitors to attend the Chautauqua on one Saturday

THE ARRIVAL OF ONE OF THE SATURDAY EXCURSION TRAINS

During the Chautauqua assemblies, the Louisville and Nashville Railroad offered Saturday excursion rates for people living in the Panhandle. The fare from Pensacola was $1, and the passengers had to return the same day. The train left Pensacola at 7:30 in the morning and arrived in DeFuniak Springs at 10:30. The return trip left DeFuniak Springs at 9:00 p.m. Service was also available from the eastern seaboard of Florida as well as northern points. A train leaving Jacksonville at 10:00 in the morning would arrive in DeFuniak Springs at 8:00 at night. Special rates were offered for those traveling longer distances to attend Chautauqua. In the early 1890s, a round-trip fare from Chicago to DeFuniak Springs cost $15.

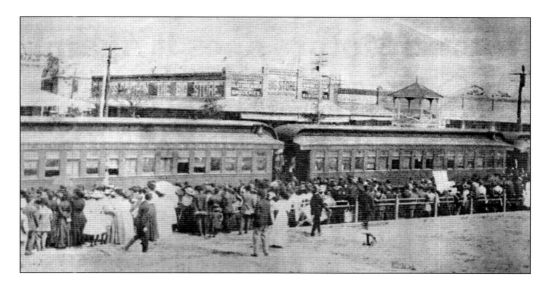

In one of her "Bits and Pieces of Walton County History" columns, Anna Reardon wrote: "Wallace Bruce was born in Hillsdale, N.Y. on January 10, 1844. He was well-educated, graduating with honors from Yale University about 1868. . . . He married Anna Becker of Scodak Depot, N.Y. about 1870. She was born October 22, 1849, and also had a good education, having attended a private 'Young Ladies Academy' in northern New York. . . . Wallace Bruce was a scholar, author, poet and lecturer. He was appointed by President Benjamin Harrison to serve as U.S. Consul to Edinborough [sic], Scotland, where the family lived from 1889 to 1893. . . . After Wallace Bruce returned to this country, he continued his career, lecturing throughout the country." The photograph of Anna Becker Bruce was taken in Edinburgh, Scotland.

Wallace Bruce had a grand vision for Chautauqua. A pamphlet was created to raise funds for the Hall of Brotherhood. It listed those who had already pledged to give Wallace Bruce $100 towards the construction of the building, including Rev. William A. Allen and John Jett McCaskill of DeFuniak Springs and two U.S. senators, George Peabody Wetmore of Rhode Island and Chauncey M. Depew of New York. The pamphlet stated, "The western wing of the Hall of Brotherhood will be known as 'Yale University Hall,' and will be dedicated to the Yale Boys of the South. It will be used as a Lecture Hall for American History and Literature, and as a reception room and rallying place for graduates and representatives of Colleges and Universities everywhere." It listed some distinguished alumni who had already subscribed, including Cornelius Vanderbilt and Wallace Bruce.

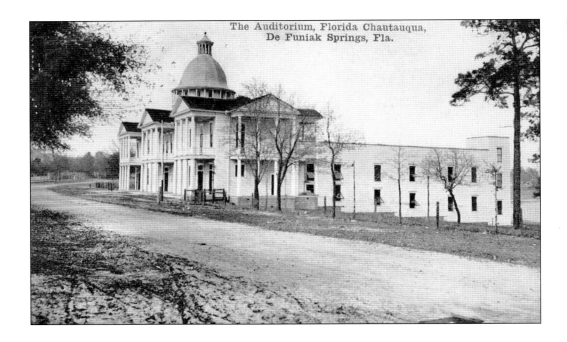

Construction of the Chautauqua Hall of Brotherhood was completed in 1909 at a cost of $28,000. The building then had a portico at each side in addition to the three across the front. Some accounts say the 40 columns supporting the porticos represent the states of the union at that time, but Wallace Bruce described his dream building to the *Cincinnati Inquirer* in 1893, "The columns on the first floor will represent the lawmakers of the world from Moses, Lycurgus and Solon to Lord Chatham and Burke; the columns on the second floor will represent American statesmen, great Generals of the Blue and Gray, and leaders of literature, science, and religious thought everywhere." The auditorium at the back of the building could seat 4,000 people. (Courtesy of Scott Clary.)

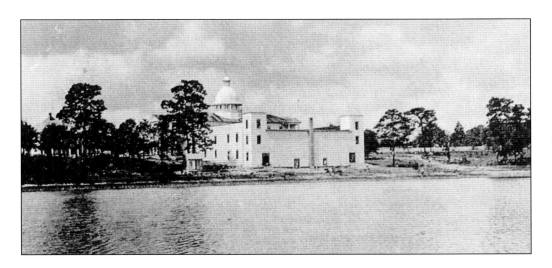

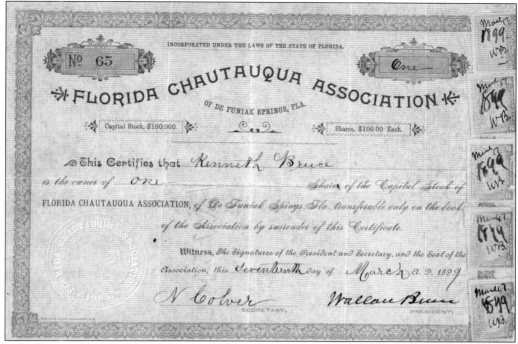

Wallace Bruce was president of the Chautauqua until his death in 1914. He had two sons and one daughter, all of whom played a part in the continuation of the assemblies. Kenneth, who assisted Wallace in the final years of his life, took over until he died two years later. Malcolm then served as president until the early 1920s, but the glory days of the Chautauqua had passed. Malcolm moved away, and his brother-in-law, Dr. George H. Abernethy, who had married Wallace's daughter Clara in 1906, became president of the association until it ceased in the late 1920s. Several attempts were made to revive the Chautauqua up until the early 1930s, including an attempt by Bruce Abernethy, son of George and Clara, but none were successful. The photograph below by George F. Carden shows the building in 1911. (Courtesy of Scott Clary.)

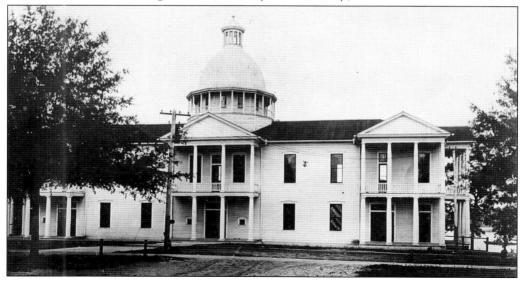

The programs for the Chautauqua Assembly from 1898 until 1913 were all very much like this one from 1907. They featured a colored cover with an advertisement for the Louisville and Nashville Railroad on the back. Inside was information about DeFuniak Springs, photographs and information about lecturers and entertainers, the complete schedule of events, and advertisements for local businesses. (Courtesy of Scott Clary.)

Four
COLLEGES AND SCHOOLS

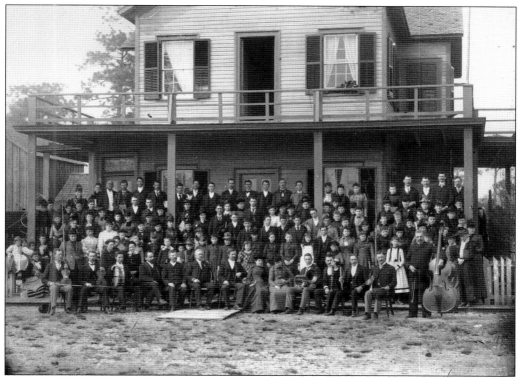

DeFuniak Springs has a history rich with educational institutions. The State Normal School was authorized by the Florida Constitution in 1885 and opened to students in 1887. At the time, it was the only school in Florida devoted exclusively to the preparation of teachers. The third man from the right in the back row is John Roderick Anderson, and the fourth man is his brother, Angus L. Anderson (1964–1948), who was later a charter member of the First Baptist Church and served in the Florida state legislature during the Catts administration.

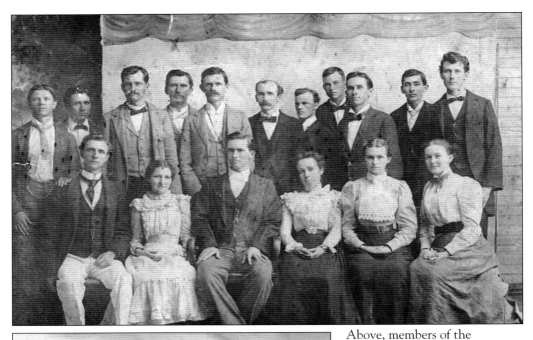

Above, members of the Delphian Literary Society of the Florida State Normal School posed for this photograph by T. Hope Cawthon in 1899, and the issue of the *State Normal Messenger* (left) is from the same year. The majority of the school's students were women, but teaching scholarships were not offered to women in Florida until 1901, when the state legislature authorized one female scholarship per year for each county. The women who accepted the scholarships had to attend the Florida State Normal School in DeFuniak Springs. When the school closed in 1905, female students were sent to the Florida State College for Women in Tallahassee, which is now Florida State University, and the men were directed to the University of Florida in Gainesville.

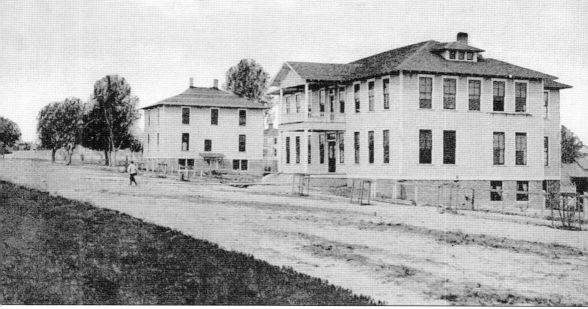

Thomas Industrial Institute, De Funiak Springs, Fla.

In March 1886, seven hundred Florida teachers and administrators met at Chautauqua for a short training period because many teachers had only attended grammar school. The meeting gave birth to the Florida Education Association. The first private school in DeFuniak Springs, the McCormick Institute, was sponsored by the Methodist Episcopal Church. It opened in 1885 and closed in 1889, when the building, located east of the present First Presbyterian Church, was destroyed by fire. Another school affiliated with the Methodist Episcopal Church opened in September 1913. The Thomas Industrial Memorial Institute (above) was named in honor of the Reverend Dr. Hiram W. Thomas, who dreamed of a boarding school that would teach farm children modern agricultural methods. He died before his dream could be realized, and his widow, Vandalia Varnum Thomas, donated land for the campus on South Second Street where several buildings were constructed. The school taught grades 1 through 12 and attracted local students as well as those from surrounding counties. It prospered for many years but closed at the end of the 1924 school year. (Courtesy of Scott Clary.)

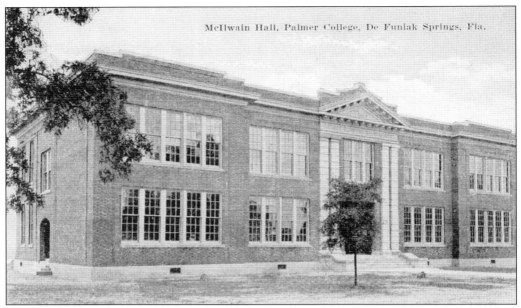

When Florida State Normal School closed, the Florida Presbytery purchased the Harriett Saunders McIlwain Hall and opened Palmer College and Academy in 1907, which offered both high school and college classes. An advertisement in 1913 stated, "Located at beautiful DeFuniak Springs, Florida, Seat of Florida Winter Chautauqua. Highest altitude in the state; no malaria; artesian water 675 feet, unprecedented health record, well equipped school buildings; two dormitories; good board; careful oversight; moderate expenses. A school with a definite aim. Devoted distinctly to genuine happy home life, thorough education and character building, through personal attention and competent instruction." Towards the end of its days, only freshman and sophomore years were offered, so it is considered to have been the first junior college in Florida. (Courtesy of Scott Clary.)

Palmer College was named for Dr. B. M. Palmer of New Orleans, the first moderator of the Presbyterian Church in the United States. (Courtesy of Jeanette Anderson McDonald.)

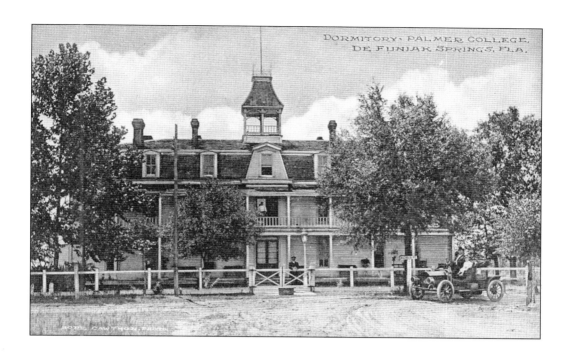

The girls' dormitory was very distinctive, as shown above. Newton Hall was the boys' dormitory and still stands on College Avenue. It was built in 1914 at a cost of $20,000 and housed 56 students. It had a suite for a teacher and family to live, and it included a gymnasium and two meeting rooms. (Courtesy of Scott Clary.)

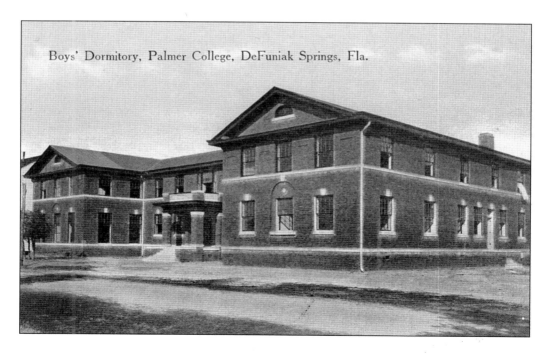

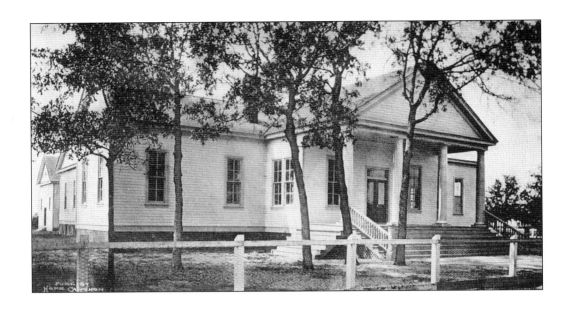

These T. Hope Cawthon photographs show the old administration building. In June 1910, a woman named Jane used the postcard below to write to a friend in Ohio, "You should be in DeFuniak now. We are having a Methodist Revival. I am sure you would enjoy it." (Courtesy of Scott Clary.)

The photograph at right appears to have been taken at the administration building after some fancywork had been added to the porch and the trees had grown. Unfortunately, in early 1915, the administration building was destroyed by fire, and other buildings were damaged. The college overcame the tragedy and prospered for many years thereafter. It closed in 1935. (Courtesy of Scott Clary.)

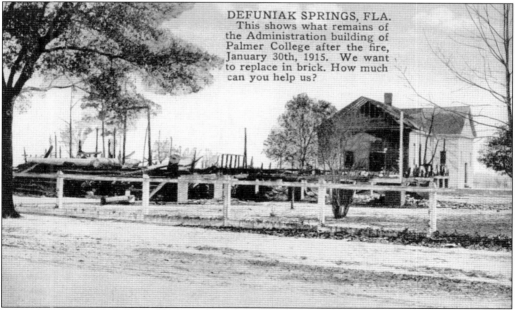

DEFUNIAK SPRINGS, FLA. This shows what remains of the Administration building of Palmer College after the fire, January 30th, 1915. We want to replace in brick. How much can you help us?

Maude Saunders was born in DeFuniak Springs in 1885. She spent most of her career teaching science and Latin at Walton High School and was promoted to principal. When she retired, Mayor Stealie M. Preacher honored her by proclaiming June 30, 1955, "Miss Maude Saunders Day." She died in 1964 at the age of 79. The first Walton High School was converted to an elementary school and was named in her honor. (Courtesy of Ann Williams.)

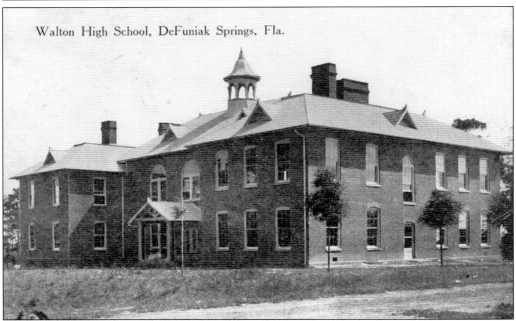

The first high school was established in 1903, and the first brick Walton High School building was built in 1909 at a cost of $15,000. It was used as a high school until 1916, when it was converted to the Maude Saunders Elementary School that was used until 1955. Another elementary school in town is now named for her. (Courtesy of Scott Clary.)

After 1916, the building above was the high school. Walton High School's first football team posed for the photograph below on the grounds of Palmer College in 1921. The linemen are, from left to right, Walter Donnelley, Theo Griffith, Fuller Warren, Ralph "Bud" McBroom, Cletus Fuqua, Clyde McKenzie, and Earnest Walker. The backs are Ralph Spiers, Buell Ogburn, Bert McCall, and Hubie "Nugget" Raburn. The substitutes are, standing, Maurice Boriens, Joe Tappen, Lewis Steele, Walker Lee Austin, and Arlin Bell.

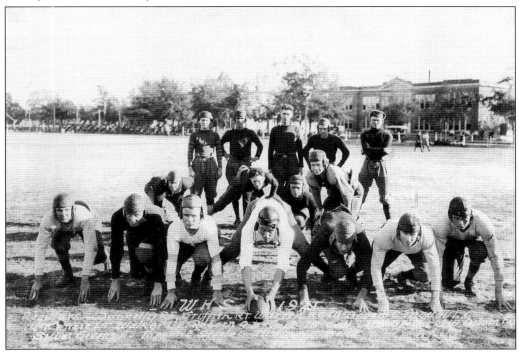

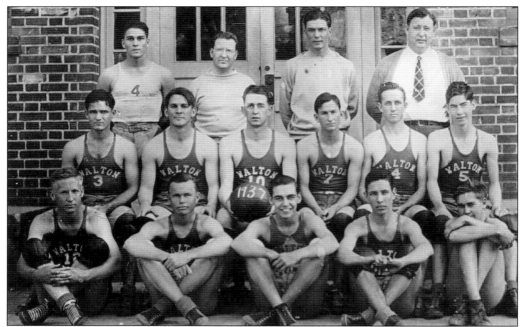

The 1936–1937 basketball team members are, from left to right, (first row) Ed Taylor, Dawson Cawthon, Gerdon Tappon, John Rutan, and Jeb Stewart Gaston; (second row) Woody Wesley, Bob Hatcher, Frank Mzwreck, Earl Wesley, Kenneth Sconiers, and Charles Taylor; (third row) Buddy Lowery and coaches Shorty Waites, Grey Wilson, and Ox Clarke. The 1937 Walton High School football team was comprised of, from left to right, (first row) William Anderson, A. D. Cosson, Vernon Cosson, unidentified, "Big Red" Cawthon, and Clyde Moretz; (second row) Kenneth "Slick" Sconiers, Dawson Cawthon, Bob Hatcher, Earl Wesley, and Herman "Buddy" Lowery. (Courtesy of Sonny Yates.)

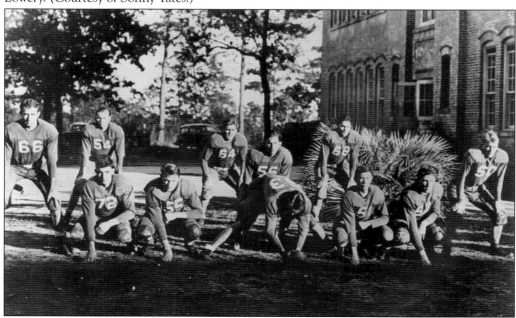

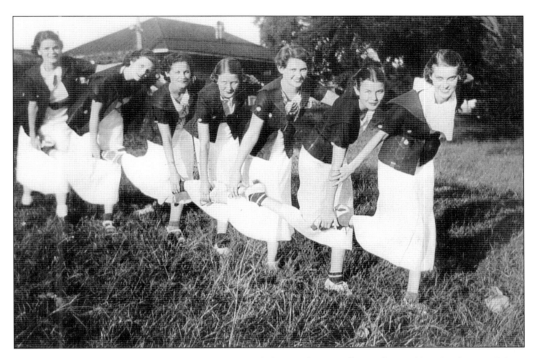

The "Berry Bunch" in 1934 and 1935 are, from left to right, Ouida Andrews, Kay Anderson, Mary Lee Garrett, Juanita Prim, Lucille Flow, Laura Anderson, and Mildred Broxson. Laura Anderson worked in the dry goods section of King and Company for most of her adult life. (Courtesy of Frances Howell Healy.)

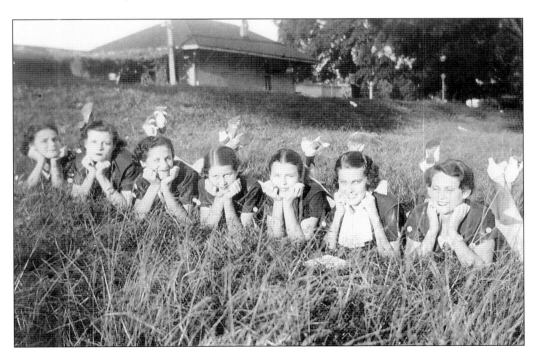

Tivoli School was an elementary and junior high school from 1912 until 1935. The 10th, 11th, and 12th grades were phased in during the 1935–1936, 1936–1937, and 1937–1938 school years, respectively. Annie Ruth Campbell has preserved the history of many black institutions in DeFuniak Springs and the surrounding area. She wrote, "Prior to the location of the school at Thomas Avenue and Park Street, classes were held in a house built by Ike McKinnon and Columbus Gipson. McKinnon donated land, materials and labor for the Nelson Avenue structure. . . . The four room school [on Park Street], built by the local school board, was later expanded by the addition of two more rooms. During several subsequent administrations, as black schools throughout the county were phased out, five brick buildings were erected on the site."

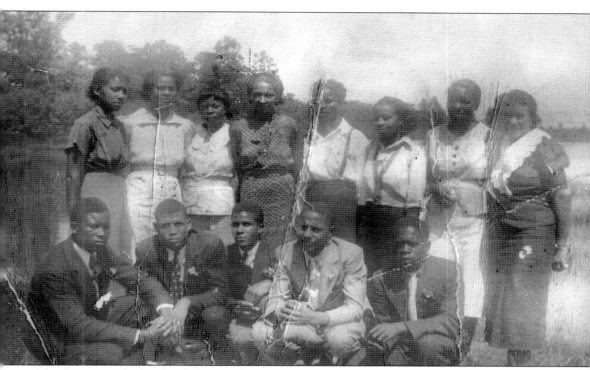

The first senior high school class graduated 12 students in 1938. The seven girls are, from left to right, Rosa Helen Jenkins, Georgia Wheeler, Lartha Wheeler, unidentified teacher, Thelma Manning, Gladys Hooks, Ruth Helen Hollis, and Freddie Mae McLean. The five boys are Burford Kidd, Shelby Campbell, Theophilus Preston "T. P." Campbell, Monroe Hill, and Jesse Ray Ingram. T. P. Campbell returned to DeFuniak Springs after attending college in Georgia and taught at Tivoli. He served as its principal from 1956 until 1969, the year the school was closed due to desegregation. Previous principals were M. L. Clay (mid-1920s–1933), Gilbert Porter (1933–January 1938), Oliver W. Holmes (January 1938–June 1940), Robert Bragg Jr. (1940–1942), William DuBose (1942–1947), Harry L. Burney (1947–1951), and Henry T. Wilkerson (1951–1956). (Courtesy of Annie Ruth Campbell.)

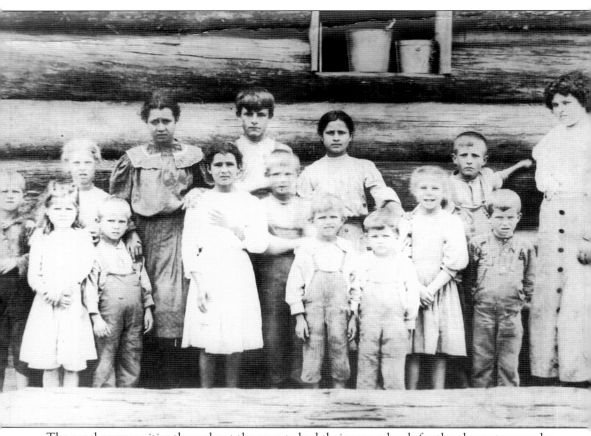

The rural communities throughout the county had their own schools for the elementary grades. The school at New Harmony, which is northwest of DeFuniak Springs, was in operation as early as 1890. It was a log cabin and had only one teacher until 1916. As children grew up, new young ones would enroll at the school, so it often changed locations to be closer to its students. The New Harmony School students in 1910 are, from left to right, (first row) Lurie Courtney, Etheridge Body, Bessie Daughtry, Monroe Adams, Carl Walden, Ceal Walden, Bessie Courtney, and Jason Courtney; (second row) Connie Daughtry, Adelia Courtney, Effie Daughtry, John Adams, Allie Daughtry, Walker Adams, and teacher Blannie Miller. (Courtesy of John D. Courtney.)

Five
AGRICULTURE

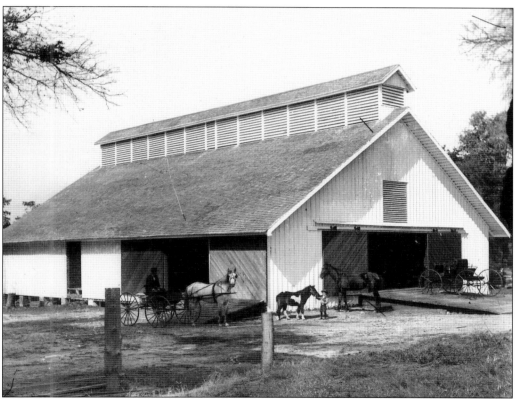

The timber and turpentine industries were natural businesses for the thickly forested acreage of Walton County. The woods were filled with pine trees and wild game, and the numerous waterways offered an abundance of fish. The demand for cane juice flourished until the early 1940s and the advent of commercial sweeteners. Other agricultural businesses in the county included poultry and dairy farms. The R. E. L. McCaskill Company stated in its promotional booklet, "All about DeFuniak Springs stretches away broad acres, some in a high state of cultivation, but mostly virgin land waiting for the plow. It is this land which offers magnificent opportunities." As this photograph of a livery stable made from one of G. Willard Shear's damaged glass plates demonstrates, the rural areas had their own brand of grandeur.

This T. Hope Cawthon photograph was taken at Smith's Dairy, which was about two miles south of the city and was started in 1906. The dairy, which closed in 1949, is said to have been the oldest continuously run dairy in Florida. The receipt below shows that a pint of milk was 7¢ in 1943. The four other dairies that served DeFuniak Springs were McCall, Thomas, Brennan, and Rutherford. (Courtesy of Scott Clary.)

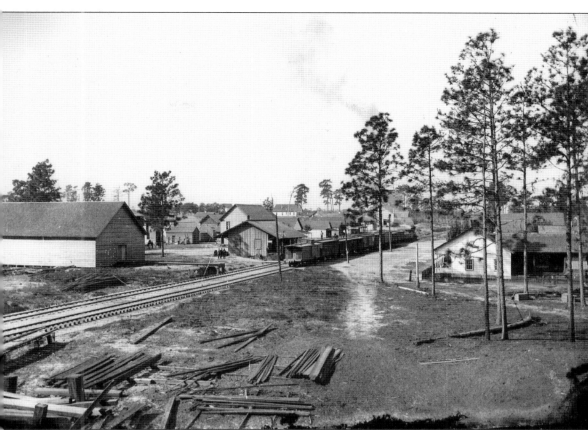

The turpentine industry was developed in this area as early as the 1870s, and the lumber mills soon followed. The location of this lumber mill in one of G. Willard Shear's glass plates is unknown but is typical of mills at that time. Trains were brought down spurs from the central track, and many of those spurs can still be located. W. B. Harbeson started a large sawmill in 1914. Its office on Baldwin Avenue is now part of the Choctawhatchee Electric Cooperative complex. In the 1930s, a fire consumed enormous stacks of lumber, and most of the mill equipment was sold in 1943.

William Rogers manufactured and distributed dressed lumber as early as 1893 under the name William Rogers and Company. His son, Henry Jewett Rogers (left), graduated from the Florida State Normal School and began teaching in Portland at the age of 19. While at a summer school course in Lake City, he met his future wife, Ruby Edwards Rose (below), and they became engaged in 1900 and married in 1903. Henry soon became the principal of Walton High School, a position he held until 1907. Ruby helped with bookkeeping at the mill and, after William Rogers died in 1915, they both worked in the business. Henry was diagnosed with tuberculosis in 1907 and was quite ill for much of his life. What remained of the business was sold in 1930, the year Henry died. Ruby taught senior English at the high school for many years. She retired in 1949 and died in 1964. (Courtesy of Rose Rogers.)

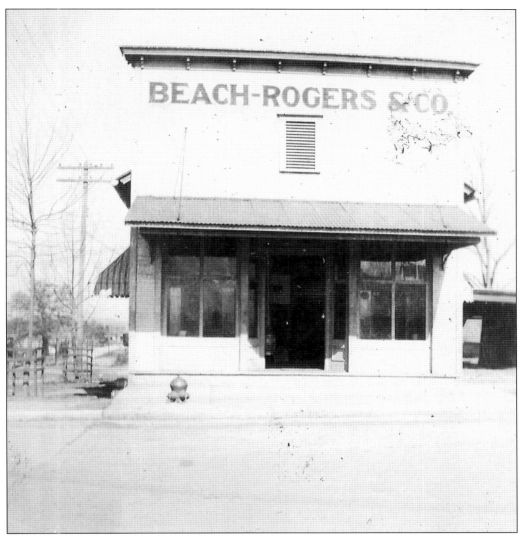

The company office was located on Baldwin Avenue, but it no longer exists. The photograph above was taken sometime in the 1920s, and below is the letterhead they used. (Courtesy of Rose Rogers.)

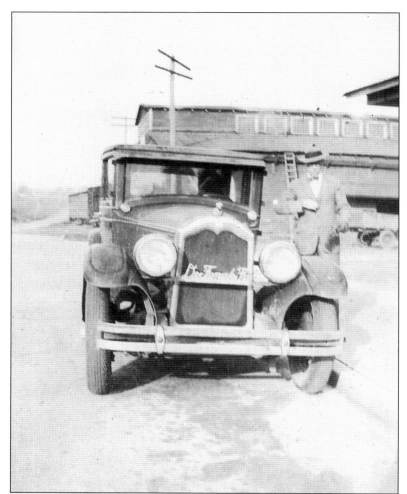

This family photograph shows Henry Rogers walking from the planing mill to his car. Railroad cars can be seen in the background. (Courtesy of Rose Rogers.)

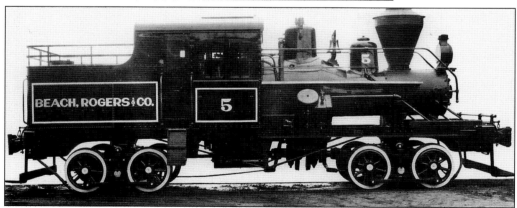

The company had its own steam engine for hauling railroad cars. The sawmills had rail spurs connected to the main lines to move the cut pine logs to their mills. They also had their own power plants and other means of hauling wood, such as trucks and tractors. (Courtesy of Scott Clary.)

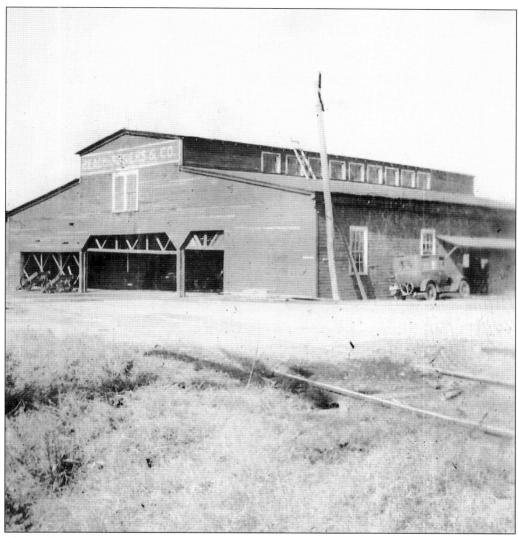

The lumber companies had two types of mills. The sawmill processed the fresh logs, which were then sent to the planing mill, where the rough-cut lumber was finished. This photograph shows the south side of the Beach, Rogers planing mill. P. W. Miles Lumber Company bought the Beach, Rogers mill in 1930. The Harbeson Lumber Company was directly west of it. (Courtesy of Rose Rogers.)

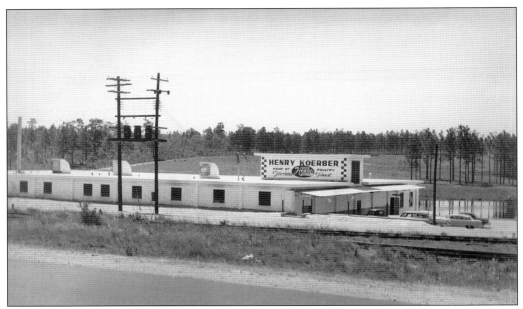

Henry Koerber immigrated from Germany in 1929 and, after working in St. Louis and Chicago, came to DeFuniak Springs to visit a friend. He soon moved here and slowly built up a chicken and feed business. In 1935, he married another German immigrant, Frieda Gleitsmann, and she helped him build the business. A small slaughterhouse was added to their property, and larger plants were built in the 1940s and in 1955. The photograph above shows the plant around 1955.

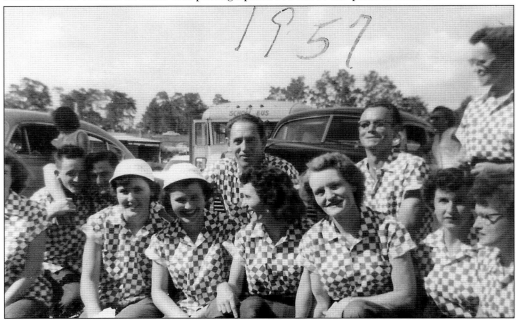

Koerber used the famous Purina brand checkerboard design as a symbol of the business, and events such as Family Day generated loyalty from the employees. In 1973, Henry sold the business to Showell Farms of Maryland, and he died three months later. Showell sold the plant to Perdue in the early 1990s, and Perdue closed the plant in 2004. (Courtesy of Lou Taylor.)

Jason C. Courtney was a farmer in New Harmony, which is northwest of DeFuniak Springs. He and his son, John D. Courtney, posed for the photograph below, showing the types of additives being used in the field. Their mule and ox often worked together, but it was an unusual combination. (Courtesy of John D. Courtney.)

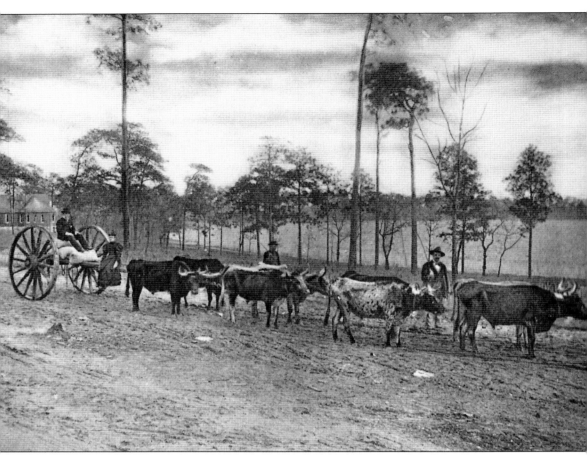

Working animals were not uncommon on the circle. This T. Hope Cawthon photograph features oxen, which were often the animals of choice in this area. Oxen worked well in teams and were more sure-footed than horses, making them less prone to injury in the sandy soil. This photograph was most likely taken around the beginning of the 20th century from the train depot. The original First Presbyterian Church building can be seen on the left, and Lake DeFuniak is in the background.

Oxen were not as fast as horses, but they could pull plows and carts harder and longer. They were especially suited to dragging logs from the forests. If a farmer could only afford one animal to plow his field, take his product to market, and run errands in town, it was likely to have been an ox. This T. Hope Cawthon photograph was taken in front of the train depot and is the only known photograph to show details of its front windows.

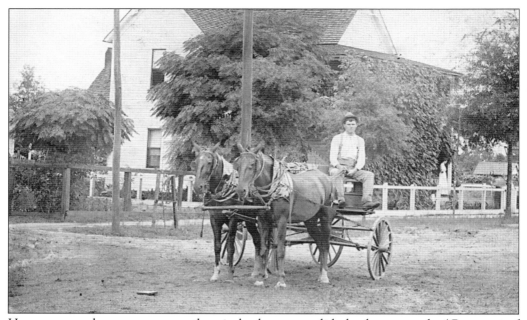
Horses were also common on the circle, but oxen did the heavy work. (Courtesy of Charles King.)

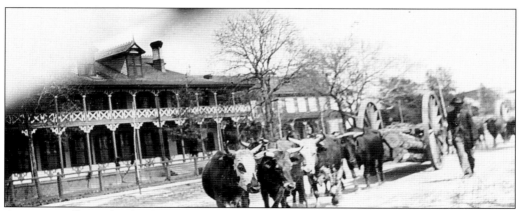
A team is pulling a load of logs in front of the Hotel Chautauqua. (Courtesy of Scott Clary.)

Six

BUSINESSES

Robert E. L. McCaskill (1871–1946) was a wealthy land developer and timber tycoon who inherited vast land holdings from the estate of his father, John Jett McCaskill. Robert McCaskill met Florence Griffin while she and her mother were visiting from New York and staying at the Hotel Chautauqua during an assembly. They married in 1895.

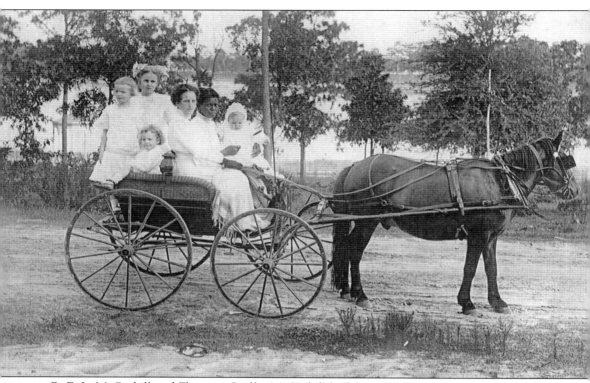

R. E. L. McCaskill and Florence Griffin McCaskill had four children. Pictured above are, from left to right, Angeline, Margaret, Evelyn, Florence, their maid, and Harold. Harold died from injuries received in a car accident in 1944. (Courtesy of Jeanette Anderson McDonald.)

McCaskill's 1920 promotional booklet, *The Road to Health, Happiness, and Prosperity*, interlaced facts and photographs with folksy prose designed to lure farmers and ranchers to Walton County. "Our interest is principally with the practical man who wants 40, 80, 160, or 640 acres for real farming, or the ranchman who wants several thousand acres, perhaps, for the grazing of his flocks and herds. But the man who merely desires to buy a few acres for fruit, nuts, poultry, or gardening, will also find here his greatest opportunity, and we are glad to supply him with just what he requires."

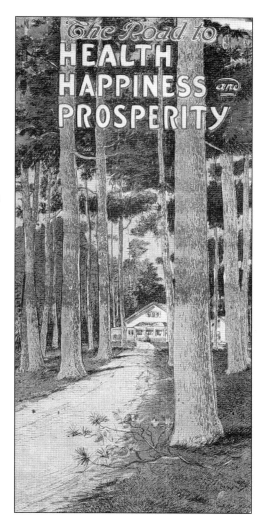

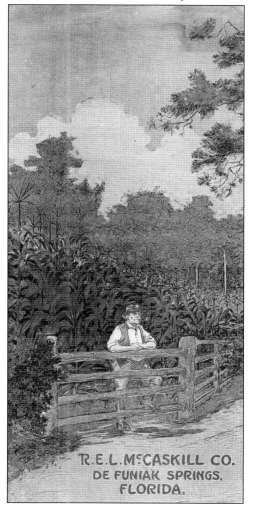

The inside cover of the booklet featured a photograph of the McCaskill home on Circle Drive, and the booklet described some attributes of the city. "DeFuniak Springs radiates that restful, cultured, friendly spirit so noticeable in most college towns. . . . Modern roads make travel easy, and modern vehicles bind country and city very closely together. You will find it pleasant to live in Northwestern Florida." Another section of the booklet points out that New Orleans is "only eighteen hours from DeFuniak Springs" and that "automobiles can make from 20 to 30 miles per hour" on its excellent hard roads.

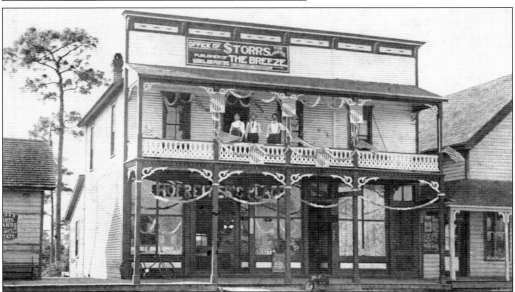

W. B. Saunders published the first issue of the *Signal* in 1884. It was the first newspaper in Walton County. In 1888, Larkin Cleveland purchased the newspaper and renamed it the *DeFuniak Springs Herald*. It has been published continuously since then and is the oldest business in Walton County. In 1892, Royal W. Storrs founded the *Breeze* newspaper. The offices were in the upper floor of the building shown above, and there was a bakery on the bottom floor. Levi Plank's real estate office was on the left, and W. C. Edge's store was on the right. In 1956, the *Herald* purchased the *Breeze*. Its final office was in the back of what is now the Triangle Chevrolet building on Seventh Street.

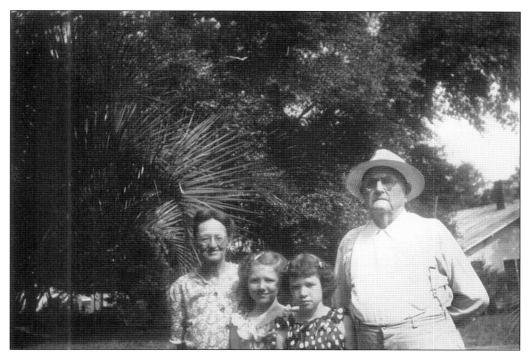

The photograph above shows Larkin Cleveland in 1947 with his wife and granddaughters, Sue and Frankie Howell. The girls were also the granddaughters of John Franklin (Frank) Howell, who served as the city clerk of DeFuniak Springs from 1927 until his retirement in 1958. The photograph at right shows Howell (left) with his son Max Howell and Max's daughter, Frankie, in 1946. (Both courtesy of Frances Howell Healy.)

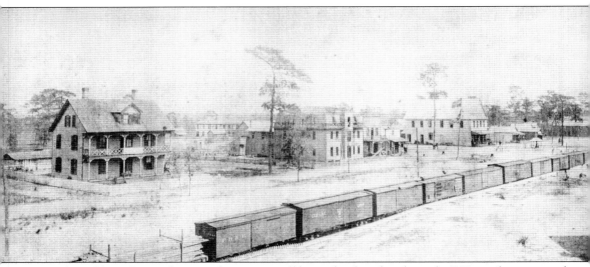

The Baldwin Avenue business district was still being developed in the early 1890s, as demonstrated by this scene between Eighth and Ninth Streets. The Lake View Hotel is on the left, the New York House is being built, and the opera house is on the corner of Eighth Street, with Murray Andrew Cawthon's store on its first floor. The Lake View Hotel is said to be the birthplace of the first child born in DeFuniak Springs, Fannie Lou Cawthon, the daughter of Joe Beauregard Burruss and her husband, Lewis Hutchison Cawthon. Fannie Lou attended the Florida State Normal School and was described as a "natural born" teacher. She contracted typhoid fever and fell deathly ill at her parents' home on Live Oak Avenue. Anna Reardon wrote in her 1982 *Herald-Breeze* article about Fannie Lou, "She was so very sick, her father asked their friends, A. L. Beach and Henry Rogers, not to blow the whistle at Beach-Rogers Mill so much." She died in 1911 at the age of 27 and was buried in Magnolia Cemetery.

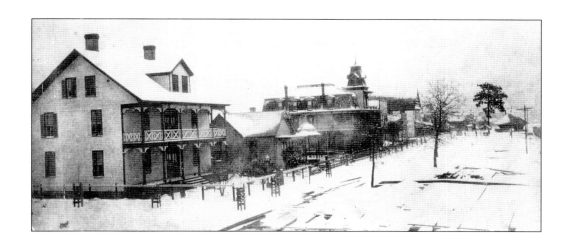

The year 1898 was eventful for DeFuniak Springs. The photograph above shows the aftermath of the big snow in the winter. The Lake View Hotel, where first baby Fanny Lou Cawthon was born, was then called the DeFuniak Springs House. The New York House can be seen with its tall, imposing tower, and the triangular front of the W. L. Cawthon building is clearly visible. A closer view (below) of the Cawthon building shows that the upstairs is the opera house. The building was purchased by Murray A. Cawthon and his son, William Lee Cawthon, in January 1887 from J. C. and Emma Peterson for $3,000. Another of Murray's sons, Burruss Cawthon, operated a general store on the first floor of the building. (Courtesy of Jeanette Anderson McDonald.)

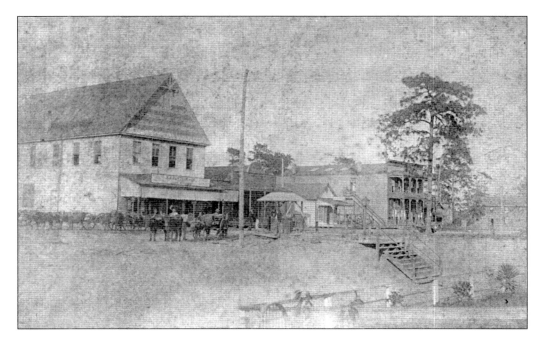

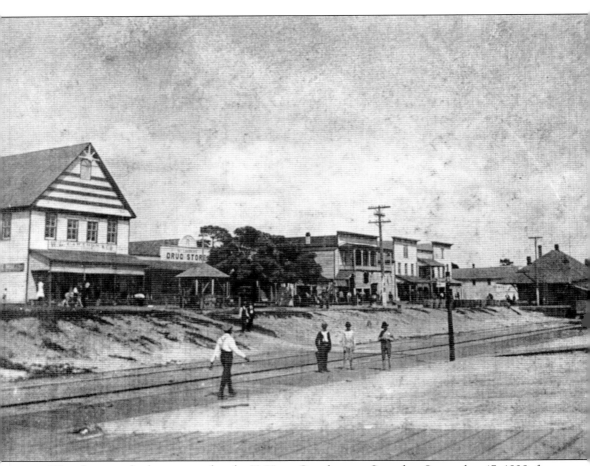

The photograph above was taken by T. Hope Cawthon on Saturday, September 17, 1898, from the post office. The block of Baldwin Avenue between Seventh and Eighth Streets was filled with businesses, and both the freight depot and a small portion of the passenger depot are visible on the right. The opera house had closed, and the building was then owned by William Lee Cawthon. His brother, Burruss, still operated a general store on the first floor. According to notes compiled by Harold Gillis, on Monday, September 19, 1898, at about 1:00 in the morning, Theo Lanz, who was a notary, was awakened by a fire alarm that was connected to his room upstairs in the Cawthon building. There was a fire in the back room of the Cawthon store. He fired his gun to sound an alarm and climbed down a post in front of the store. (Courtesy of Jeanette Anderson McDonald.)

Harold Gillis noted, "The intense heat from the Cawthon building soon fired the meat market of D. L. McLeod on the corner and rapidly did it move eastward. . . . The freight depot had . . . been ignited and was in ruins. The passenger depot was in jeopardy but was saved. The stores and offices south of the railroad were at different times on fire. The post office was low and could be reached but in spite of this it seemed determined to go. The Chautauqua hotel was on fire several times but was saved." After the last ember was extinguished, a total of 28 structures had been destroyed, including some homes, the Cawthon building, Landrum's Drug Store, the New York House, and the Lake View Hotel. The photograph above was taken by T. Hope Cawthon from the same location on Monday morning, September 19, 1898. (Courtesy of Jeanette Anderson McDonald.)

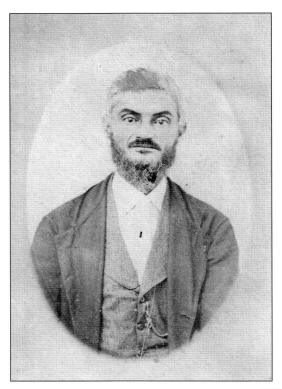

Dr. Daniel L. Campbell (1833–1922) had the first pharmacy in DeFuniak Springs. His father was Daniel Douglass Campbell, who with his brother-in-law, Neil McLennan, were the first white settlers in Walton County around 1818. Dr. Campbell was a graduate of the medical school in Charleston, South Carolina, and was a horse-and-buggy doctor. In addition, he helped establish Presbyterian churches in Freeport and DeFuniak Springs. He also served in the Florida legislature in 1872. Daniel L. Campbell's niece, Sarah Jeanette Campbell (below, right) attended the Florida State Normal School in DeFuniak Springs and the Florida State College for Women in Tallahassee. She was the first female to own an automobile in Walton County and she taught school in Red Bay, Quincy, and Millville (Panama City). Her husband, John F. Steedley, worked as the commissary manager for Harbeson Lumber Company in Harbeson City (Carrabelle). (Courtesy of William Steadley-Campbell.)

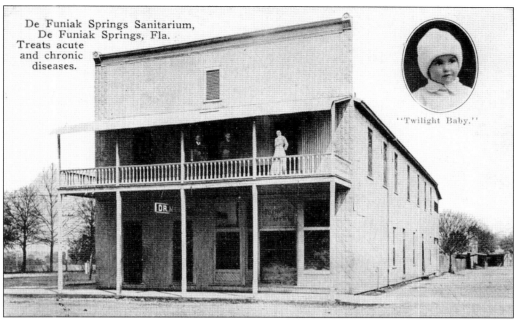

In 1897, two doctors opened a sanitarium. An advertisement for their business stated, "This Hotel and Sanitarium . . . just finished, is new, fresh and clean throughout, and is owned and conducted by Dr. G. P. Morris, president of the Florida State Board of Medical Examiners, also president State Medical Association. The Doctor's wife, who is a registered physician, is associated with him in the treatment of all chronic diseases." The sanitarium is pictured above in a 1913 postcard. The building burned down in 1946 while being used by the state welfare office.

Dr. Landrum rebuilt his office and drugstore soon after the fire of 1898. This photograph was taken in December 1910, right after their busy Christmas season. The doctor's office was through the door on the left, and his laboratory was on the right.

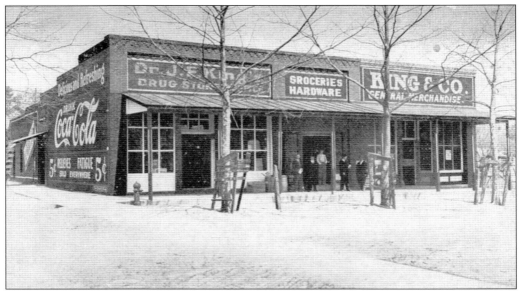

King and Company opened on December 12, 1899, as a general store run by M. T. "Tom" King, whose father and two uncles were partners. The store was located at the corner of Baldwin Avenue and Sixth Street, and the building still stands. (Courtesy of Scott Clary.)

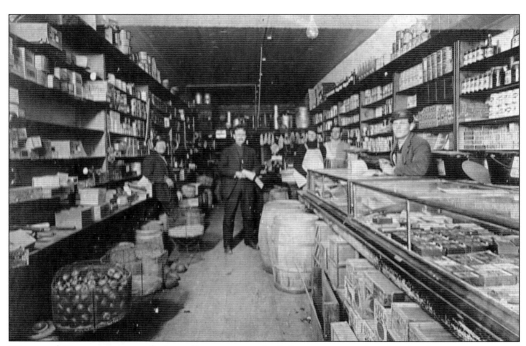

King and Company served virtually every need of the townspeople with its drug, grocery and hardware, and general merchandise stores. Prior to the availability of electricity, it had its own calcium carbide generator in a small building behind the store that provided acetylene gas for lighting. (Courtesy of Charles King.)

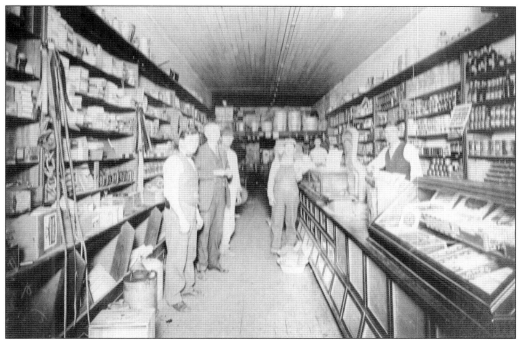

Wayne Linke wrote about King and Company in 1990: "In earlier times, a larger line of merchandise was carried, including dry goods, clothes, hardware, groceries, feed, seed, and fertilizer. They also sold eggs, of which many came from the henhouse behind the store. Live chickens were also sold. The chickens are long gone, but the henhouse is still in use as a storage shed." (Courtesy of Charles King.)

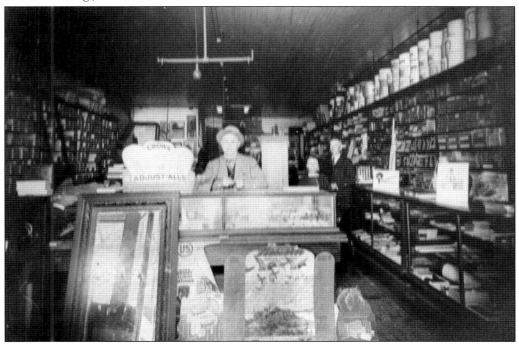

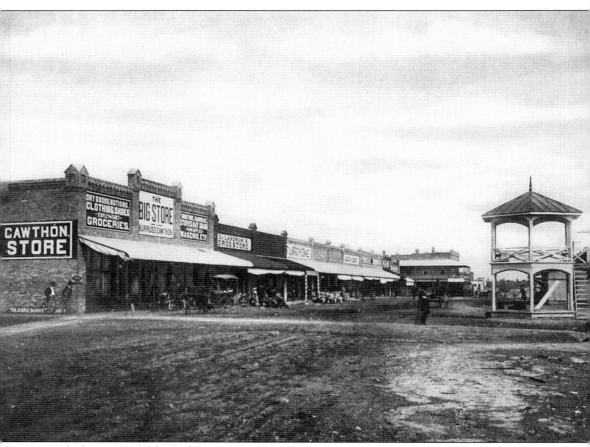

At the beginning of the 20th century, the business community in DeFuniak Springs had recovered from the fire and was thriving. Burruss Cawthon's general store had become the Big Store, Dr. Landrum's drugstore was in the next building, and William W. Flourney had built the large building that can be seen at the beginning of the next block. Flourney served as mayor of DeFuniak Springs three times: 1908–1910, 1916–1920, and 1934–1935.

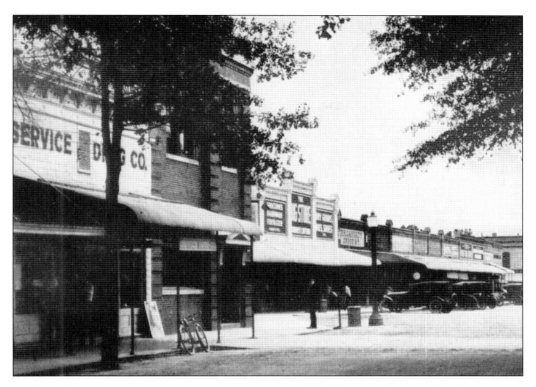

Baldwin Avenue was the center of commerce in the 1920s. Cawthon National Bank was to the right of Service Drug Company on this block, which was commonly known as the Murray Block because Charles Murray Sr. bought most of it after the fire in 1898. Abernethy and Walden Company advertised that it was located on the Murray Block in a series of ink blotters featuring various Native American maidens. The one below from 1926 identifies the maiden as Adiva, "Chief Woman." (Courtesy of Scott Clary.)

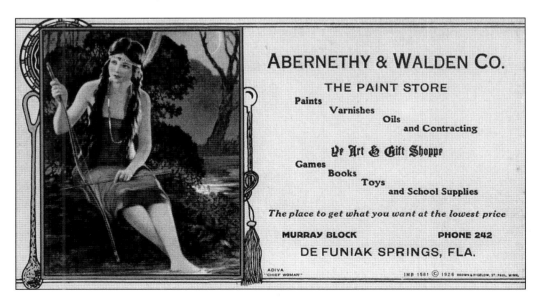

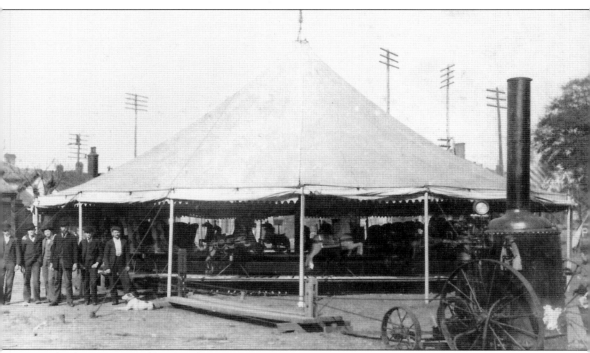

Charles Murray and his family moved to DeFuniak Springs from Wilkes-Barre, Pennsylvania. He set up a merry-go-round, skating rink, and shooting gallery in an open pavilion on the Murray Block in hopes of attracting tourists. He would often take the merry-go-round to other locations, such as state fairs. According to Anna Reardon, Murray's son Harry had a restaurant with a soda fountain on the Murray Block. "Passenger trains made regular stops here for meals, as they didn't have dining cars. One of the delights of the pleasantly cool evenings was to meet the 6:00 PM train and watch the passengers and railway crew go to Murray's Restaurant for supper." Harry Murray was the first to build a movie theater in DeFuniak Springs. The first theater was upstairs in the McCaskill Building (originally the Flournoy Building) at the corner of Baldwin Avenue and Seventh Street. He later converted the merry-go-round pavilion into a theater before building a new theater in 1921.

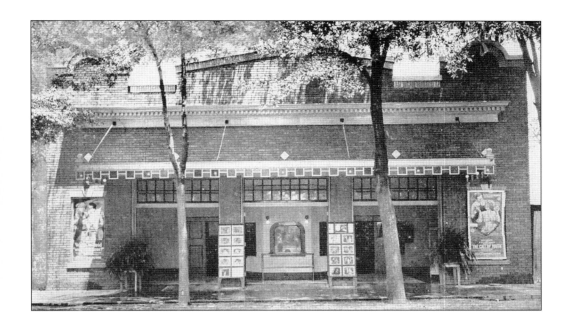

Murray's Theater was built in 1921 and later became the Ritz Theater. In the 1990s, the theater was restored through the efforts of the Walton County Heritage Association. It is now called the Chautauqua Theater, and it is still used for movies and theatrical performances.

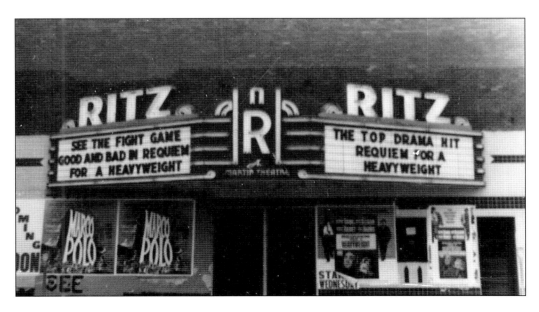

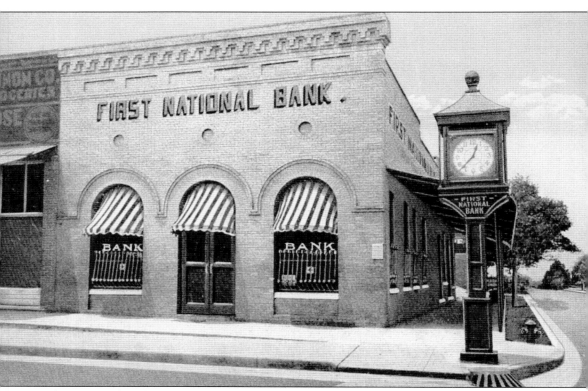

This postcard of the First National Bank shows the clock that still stands on the sidewalk at the corner of Baldwin Avenue and Seventh Street. According to the bank's 75th anniversary booklet, "Purchased in 1924, the clock was made by the firm of O. B. McClintock. It is in a cast iron housing and post, and its four faces point north, south, east, and west. The minute and hour hands are activated by an electrical mercury switch and the hands on each of the faces move abruptly, rather than gradually, to the next minute and hour. Standing twelve feet tall on the corner, it has witnessed many changes to our community and our bank." The bank building has been replaced by another structure that serves as a legal office. The clock no longer works, but some concerned citizens are trying to have it restored. (Courtesy of Scott Clary.)

George R. Paul owned the Sanitary Market. He is sitting on the mule in the photograph below. The other members of his family shown are, from left to right, his wife, Della; baby Margarite; Thelma, Bernice, and Mabel; and Della's mother, Mary Stevens. (Courtesy of Voncille and Roy McLeod.)

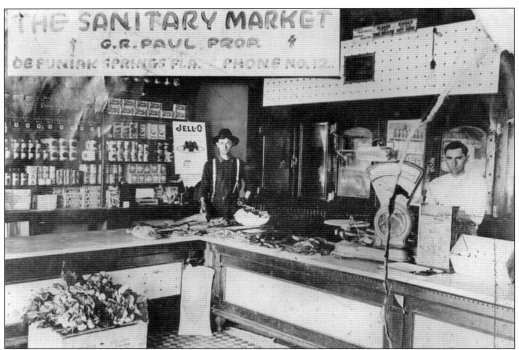

George R. Paul is seen on the right above in a later photograph of his business. The interior of the first store owned by Robert Lee Sellars is shown in the 1929 photograph below. Sellars is standing on the left, wearing an apron over his dark suit, and his employee, Howard Langley, is standing on the right. The store was located on Sixth Street between Baldwin and Nelson Avenues.

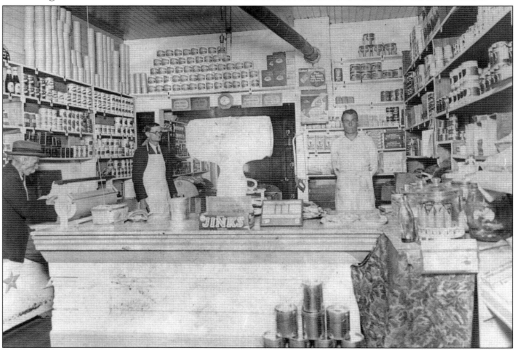

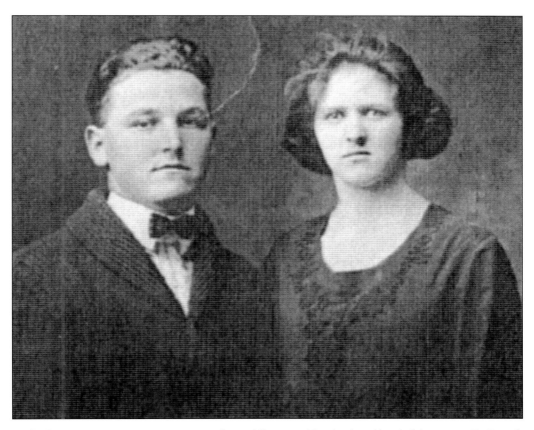

In the late 1920s, Carrie "Fennie" Humphries Allison and her husband hauled fruit up to DeFuniak Springs from central Florida and sold it out of the back of their truck. They liked the town and moved to DeFuniak Springs in 1931 with their two daughters to open a small business. Allison's Grocery grew to become a full grocery and dry goods store at the corner of Nelson Avenue and North Ninth Street. Fennie Allison was beloved because she often saw families through hard times by extending liberal credit to mill workers and their families. Allison's delivered groceries by bicycle and truck. From 1937 until 1941, Leon Richards rode the delivery bicycle and Elbie Hardy drove the truck. Due to her declining health, Allison closed the store in 1992 after being in business for 61 years.

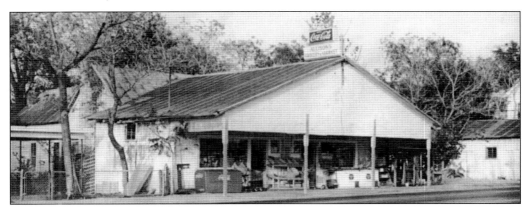

Rubye and Talmer Walden moved to DeFuniak Springs in the early 1930s to open an automobile dealership and a gasoline distributorship. Talmer died a year later, and Rubye requested that the gasoline business be transferred to her name. The Gulf Oil Company had never had a woman dealer and refused her first request, so she had a male employee sign the papers. Her transfer request was granted sometime later, so she officially became the first woman distributor of Gulf Oil in the country. In 1947, she married the man who was running the business, Nelson Burton, and concentrated her talents on other projects. She became known as "The Lady of the Lake" for her constant care of the landscaping in the lakeyard. She died in 2001 at the age of 101. The gasoline station she built is still in existence on Nelson Avenue at Eighth Street but is now used for other businesses.

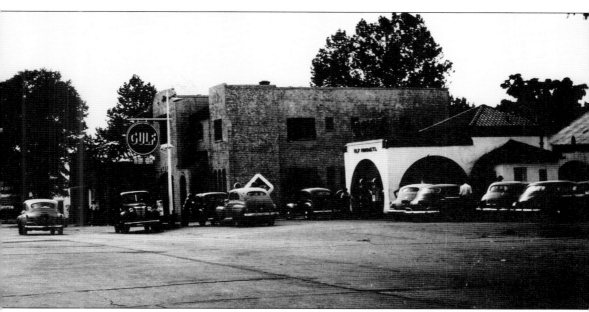

The large two-story building in the center of this photograph was city hall; it also housed the health department and the fire house. Ironically the building burned down in the 1960s. In front of it is the white building that Rubye and Talmer Walden built as a gas station. That building still stands and is currently in use but has had sections added over the years.

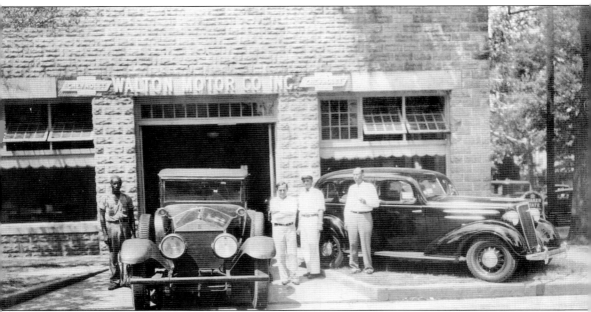

Walton Motor Company was one of several automobile dealerships in DeFuniak Springs over the years. In this T. Hope Cawthon photograph, Bryant Ray is the second man from the right and James Bullard is on the far right. James and his brother, Albert, owned the business. The building was made of petrilite, which was manufactured in DeFuniak Springs by the Southern Petrilite Company. Prior to 1940, the Bullard brothers sold the business to another set of brothers, Adrien and Armond Rivard, who changed the name to Rivard Chevrolet. The building is now home to Triangle Chevrolet Company on the corner of Seventh Street and Nelson Avenue.

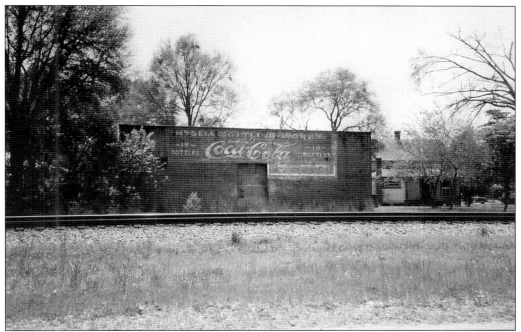

Charles Rainwater and J. H. Edmondson bought the new Pensacola Coca-Cola franchise in 1924 and changed the name to Hygeia Coca-Cola Bottling Works. For years, the bottles were shipped from Pensacola to the warehouse on Main Street in DeFuniak Springs (above) by rail. Boxcars were left in front of the warehouse, allowing workers to unload new products and reload the cars with the empties. Deliveries were made throughout the county by truck. (Courtesy of Scott Clary.)

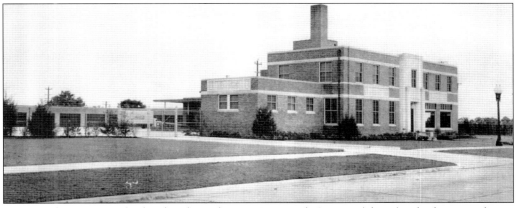

In 1941, the company built a bottling plant in DeFuniak Springs (above), which is now home to Sterling Lumber Company on North Ninth Street. The managers were Harry Robinson (1941–1946), R. M. "Shine" Sawyer (until the early 1970s), Bob Vining (until 1975), and John Poss, who managed the plant until it closed in 1979.

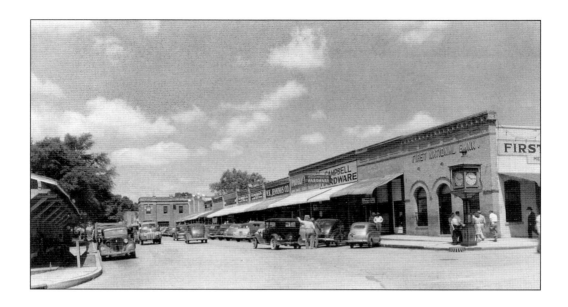

These scenes from the late 1940s show opposite views of the same block of Baldwin Avenue between Seventh and Eighth Streets. The photograph above gives a good view of the First National Bank (founded 1904), whose building was later destroyed by a fire. The freight depot is on the left, and the Cawthon State Bank (founded 1906) is in the large two-story building in the distance. The Big Store appears on the left in the photograph below, and the First National Bank clock is visible at the end of the block. In September 1936, at the age of 90, Perry Lewis Biddle performed a horizontal handstand using one of the posts that supported the Big Store awning. The feat later made the pages of a *Ripley's Believe It or Not* book in which Biddle was called the "Human Flag." (Courtesy of Scott Clary.)

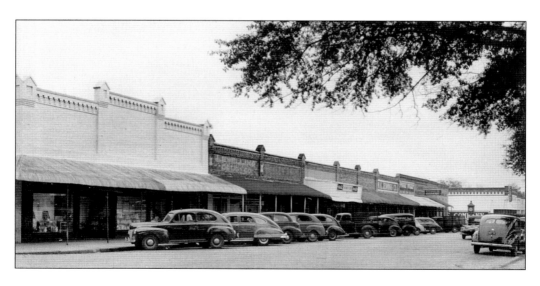

Seven

HOMES

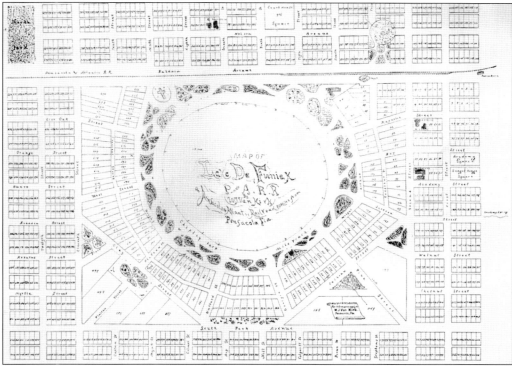

The city of DeFuniak Springs is centered around Lake DeFuniak. The plan for the city, which was originally drawn in 1884 and revised in 1886 by William J. Van Kirk of the Lake DeFuniak Land Company, detailed the layout of 208 acres surrounding the lake. W. J. Van Kirk, land agent for the Pensacola and Atlantic Railroad, envisioned a grand circular drive around the lake with streets branching out to two other nearly circular drives before intersecting with rectangular blocks. Chipley Park, the landscaped area now commonly called the lakeyard, is about 250 feet from lake to roadway and includes walkways and an amphitheater. It was named in honor of William Dudley Chipley, who managed properties for the railroad. Under his leadership, the railroad built warehouses, wharves, a grain elevator, and a coaling station in Pensacola so that it became a thriving port. When the Florida legislature granted the Florida Chautauqua its charter, it also created the Lake DeFuniak Land Company with Chipley in charge. Chipley later served in the Florida Senate from 1895 until 1897.

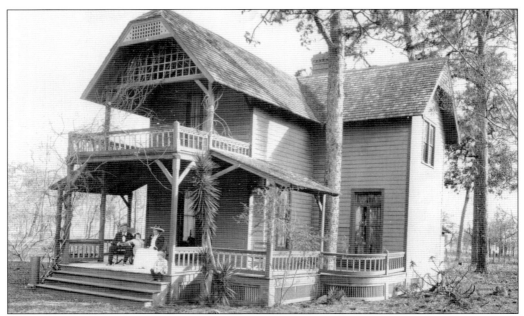

The Dream Cottage, which was built in 1888, is the second oldest home on Circle Drive (c. 1888). Wallace Bruce built this Gothic stick-style house for his wife and children. He also purchased parcels to create Alpine Spring and Park (below), which was a short walk from Lake DeFuniak. The well curb was made of granite blocks from South America given to him by a friend in Pensacola. As the sign indicates, the spring was dedicated to his mother's memory. About 1910, the Dream Cottage was given to his son, Malcolm Bruce, who lived there with his wife, Olive Rogers. Anna and Wallace Bruce then lived in the Hotel Chautauqua until they remodeled the Chautauqua arts and crafts building, where they lived for the remainder of their lives.

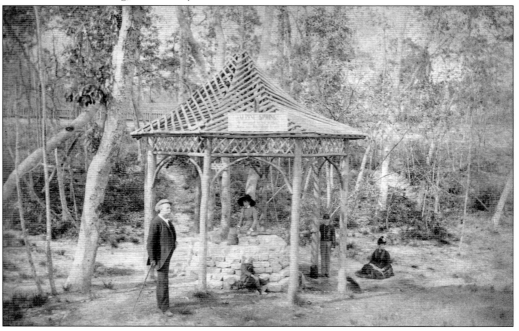

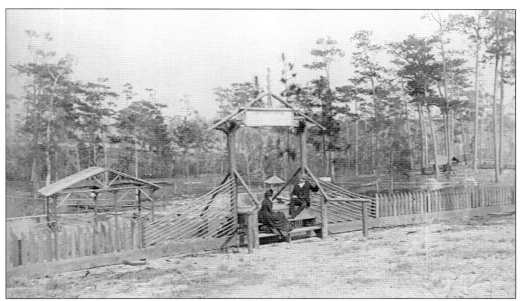

Wallace Bruce and his wife, Anna, are shown in Alpine Park in this photograph by G. Willard Shear.

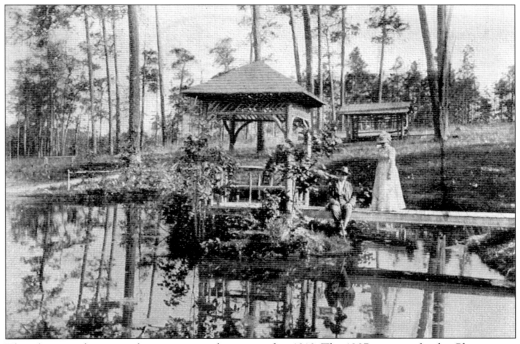

This photograph appeared on a very popular postcard in 1910. The 1907 program for the Chautauqua Assembly described Alpine Park: "Adjoining the Chautauqua Park and Lake, is a delightful resting-place where the lover of nature can walk among stately pines, bask in the sunshine and hear the sweet music of song-birds mingle with the cadence of falling waters. Here is Alpine Spring, the crystal water of which is caught in a 'Jacob's Well' of sparkling granite." (Courtesy of Scott Clary.)

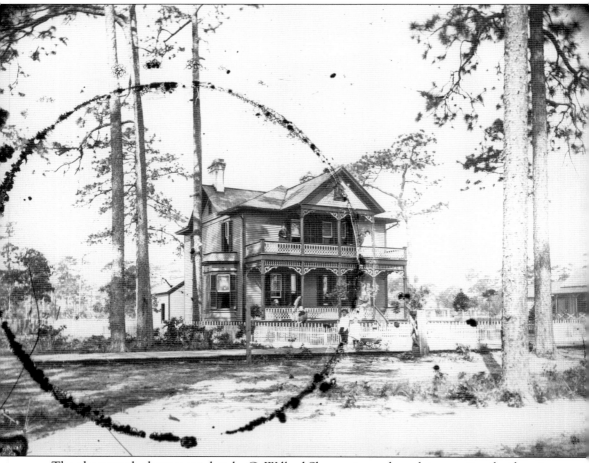

The photograph above was taken by G. Willard Shear using a glass-plate negative that has since been damaged. It was identified in the 1892 *Florida Chautauqua* quarterly as the "winter residence of Mrs. R. L. Storrs, of Chicago." J. Albert Smith wrote that she "has for years been troubled with malaria and catarrh. She has plenty of earthly means, and has sought relief in Southern California, Eastern Florida, Colorado, Italy and other places. They all failed to give her the boon sought for. At deFuniak Springs, however, she enjoys perfect freedom from these troubles. She goes out nights with impunity, and though advanced in years, seems to be enjoying a renewed youth."

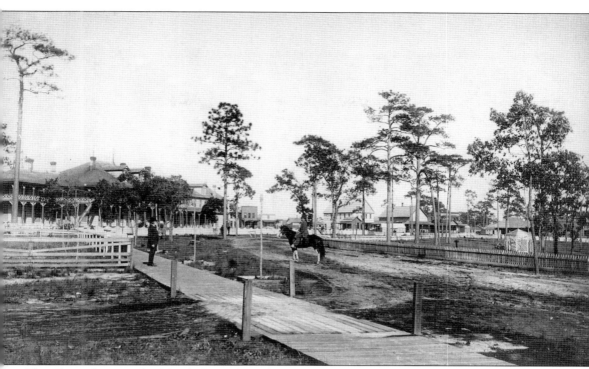
This Shear photograph of Circle Drive from the Van Kirk Cottage shows the Hotel Chautauqua and a glimpse of Baldwin Avenue in the distance.

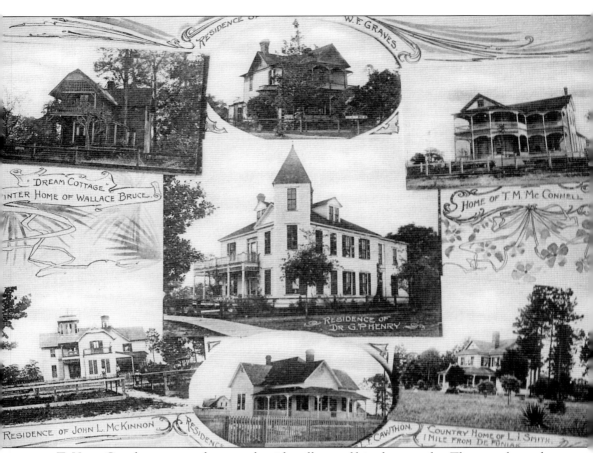

T. Hope Cawthon prepared postcards with collages of his photographs. The one above shows some of the homes in DeFuniak Springs, and he published others of the churches and businesses. The home in the upper right was built of virgin heart pine in 1902 by Thomas M. McConnell, a wealthy turpentine dealer. The home in the middle was once the home of Dr. George Pomeroy Henry and later of G. Bowers Campbell.

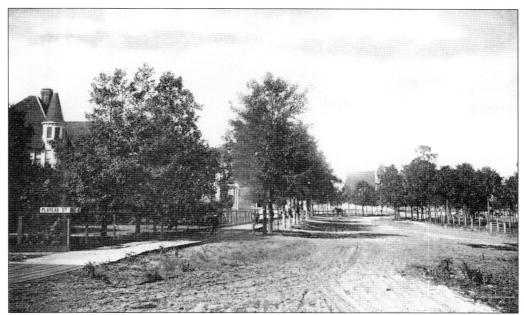

These street scenes by T. Hope Cawthon give a sense of what Circle Drive was like prior to being paved. Some of the architectural styles represented on the circle are Colonial Revival, Folk Victorian, neoclassical, and Queen Anne. The Thomas McConnell home, which is depicted on the postcard opposite, is a good example of Folk Victorian styling. The Chautauqua Hall of Brotherhood is one of only eight buildings in DeFuniak Springs to feature neoclassical styling. It was listed on the National Register of Historic Places in 1972. The turret visible on the left of the photograph above belongs to the Thomas House, which was built about 1895 in the Queen Anne style.

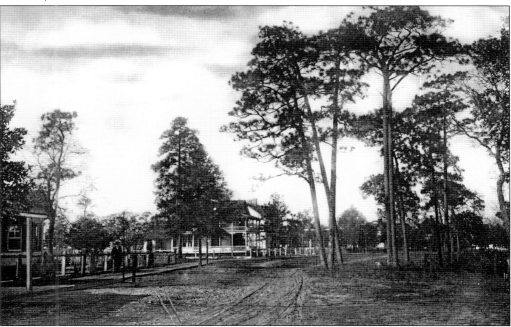

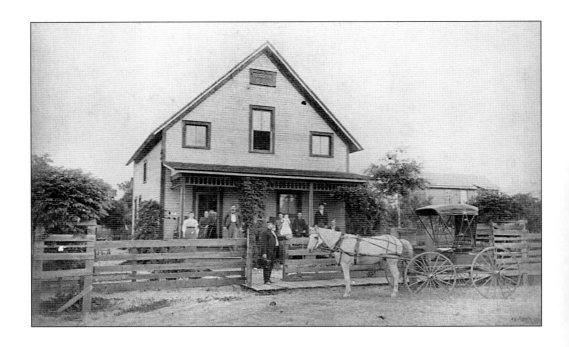

The residence of James A. McLean (above) was modest by Circle Drive standards. He also owned the "dwelling house" below. It was probably located across from the Walton County Courthouse. McLean was the clerk for the circuit court and was in partnership with attorney D. Campbell for many years, advertising they would "give special attention to the assessing and payment of taxes and collecting of rents."

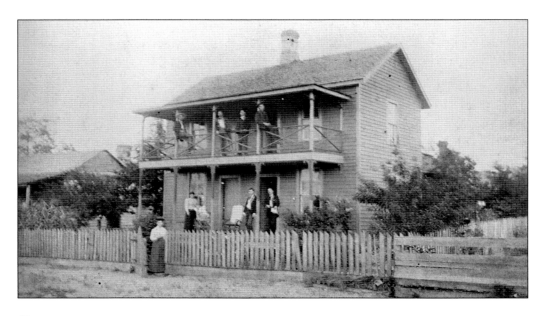

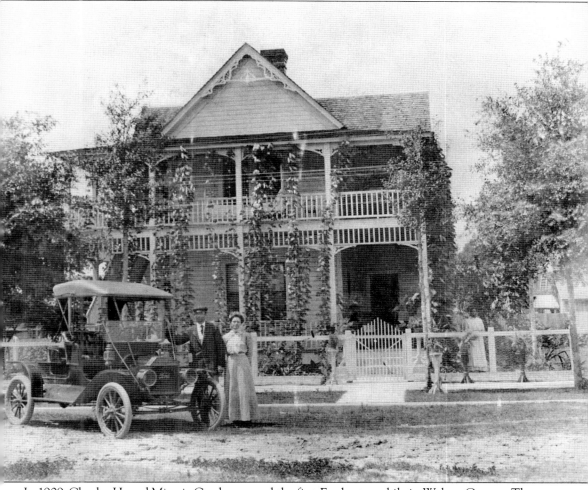

In 1909, Charles H. and Minnie Gordon owned the first Ford automobile in Walton County. The automobile cost $900 plus shipping charges. It was shipped from Atlanta, Georgia, to Pensacola, Florida. It then traveled by boat to Freeport in Walton County, and Charles Gordon drove it from there to DeFuniak Springs. It was kept in the garage belonging to Tebbie Cawthon until the Gordons had their garage built. Charles Gordon was the clerk of the court for Walton County. The Gordons purchased their home in the spring of 1909 from Walter Mathews and lived there until 1925. Their home was one of 17 buildings in DeFuniak Springs of the Folk Victorian style, one of the oldest and most popular "high style" architectural types in the city. The home is now the Fellowship Hall for the First United Methodist Church.

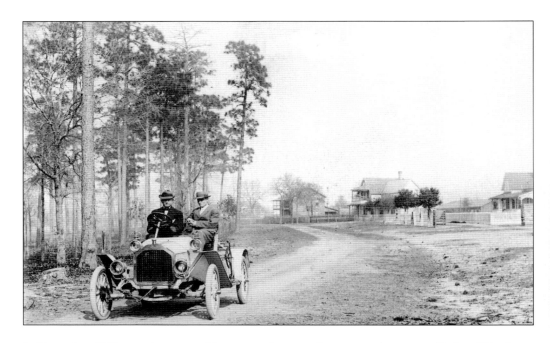

In December 1909, a student named June wrote home to Iowa using the postcard below. "Don't you think this looks like a Chalmers [automobile]? It can hardly get thru the sand here." That same month, photographer George Carden used the same photograph to promote his business to Otto Fisher, a teacher at Palmer College: "We take pleasure in inviting you to visit our Studio before selecting your Xmas presents. We have an attractive, dainty & useful line at moderate prices. Do not fail to inquire about our valuable free gifts. Geo. F. Carden." Circle Drive was originally called Wright Avenue in honor of Thomas T. Wright. Several sections of the walk around the circle were paved in 1910, and "Wright Avenue" was stamped in several places that remain visible today. The avenue was paved in 1928. (Courtesy of Scott Clary.)

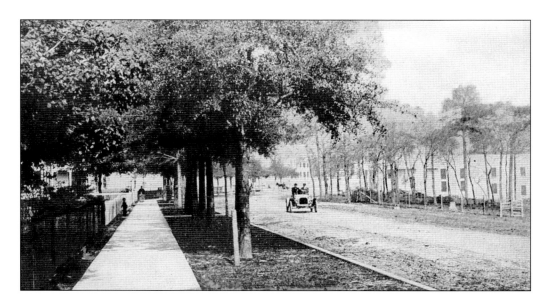

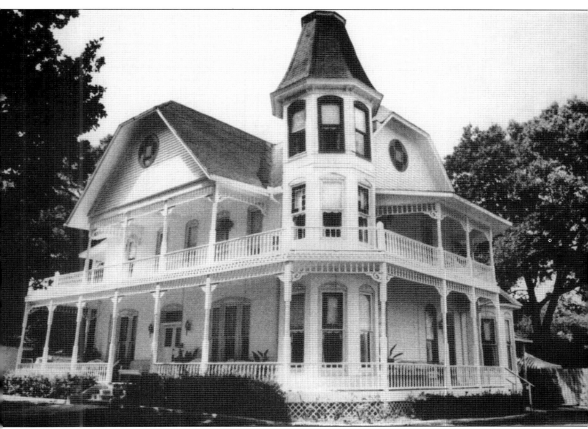

Sunbright Manor was purchased by former Florida governor Sidney J. Catts in 1924, and he lived there until his death in 1936. Construction on the house started about 1886, and it was completed around 1890. The original owner was J. T. Sherman of Brodhead, Wisconsin, who used it as a winter residence for his family. The exterior of the home has a tower and porches with 33 columns and 1,600 spindles.

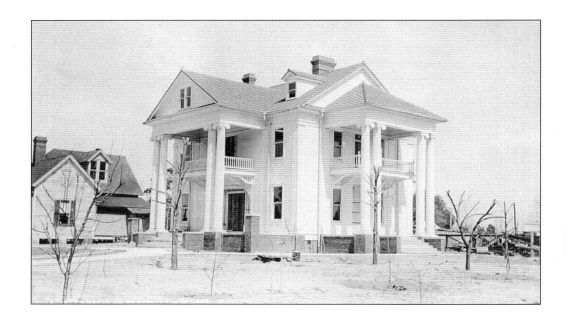

This American classical-design house on Circle Drive was built about 1901 and appears above around 1910. Stuart Knox Gillis, a teacher and prominent attorney, was the original owner. The French red-tile roof was a unique feature for homes at the time. Mae Gillis stenciled the walls of the first floor rooms, a decorative technique that was quite unusual then. After the Gillises died one week apart, the house was given to Palmer College to be used as the home of its president. Marshall Lightfoot, the owner of Lightfoot's Drug Store and Lake Hotel at the corner of Nelson Avenue and Eighth Street, owned the home when the photograph below was taken. (Courtesy of Scott Clary.)

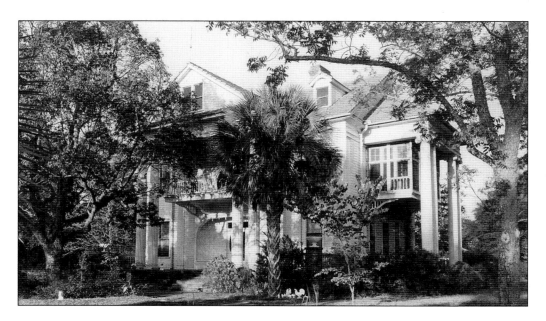

Mary Lou Cawthon (left) is shown sitting on the front porch of her father's home with Nancy Manning and in her father's car, which was one of the first in DeFuniak Springs. The Cawthon home was on Nelson Avenue, next door to the current Thriftway Supermarket. Mary Lou was the youngest of 10 children of Murray Allen Cawthon and his wife, Mary Jane Williams. Her older brothers included William Lee Cawthon, founder of Cawthon State Bank; John Crenshaw Burruss Cawthon, owner of the Big Store; Walter Clayton Cawthon, who assisted his brother Burruss with the Big Store; and Thomas Hope Wesley Cawthon, the prominent photographer. (Courtesy of Jeanette Anderson McDonald.)

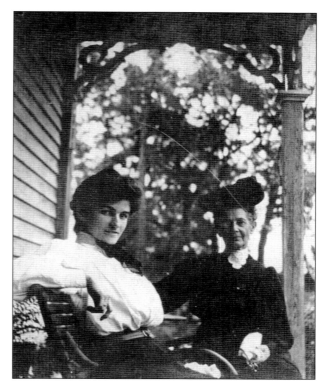

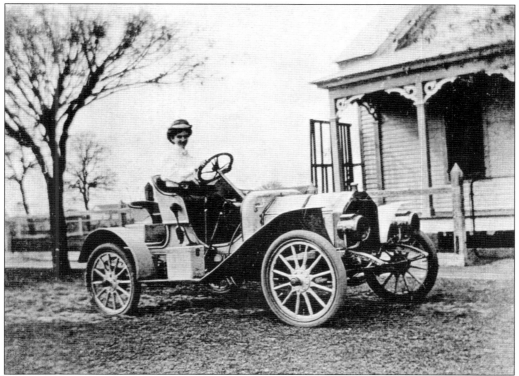

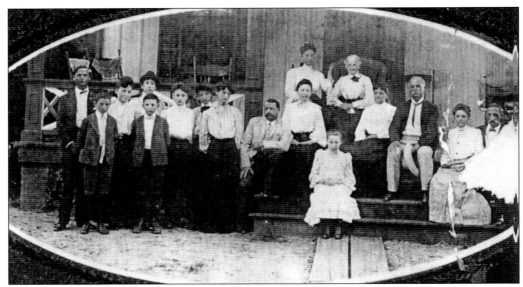

In 1903, T. Hope Cawthon captured Sarah Alice Palmer Richardson (seated, top row) on her 70th birthday. Richardson and her daughter, Mary Sydney "Mollie" Richardson (next to her), were living at the Furnace Cottage on Circle Drive. The others are Sarah's three sons—Plowden, David, and Julius—and their families (left to right): Johnnie Richardson, Hal Richardson, Eva Richardson, Ruth Richardson, Weston "Bubber" Richardson, Annie Bacon Richardson, Mary Richardson, Plowden Richardson, Susan Richardson, Julia Richardson, David Richardson, Orie Richardson, and Julius Richardson. The girl on the steps is Mary Davis, niece of Susan Richardson. Mollie later bought the home on the circle that now serves as the parish house for St. Agatha's Episcopal Church. The photograph of Sarah (below) was taken in the parlor, and Annie Bacon Richardson married William Marlin Richards in that room in 1911.

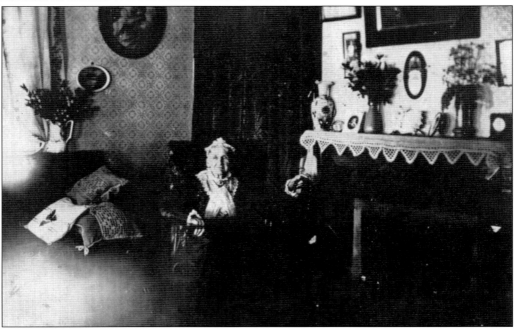

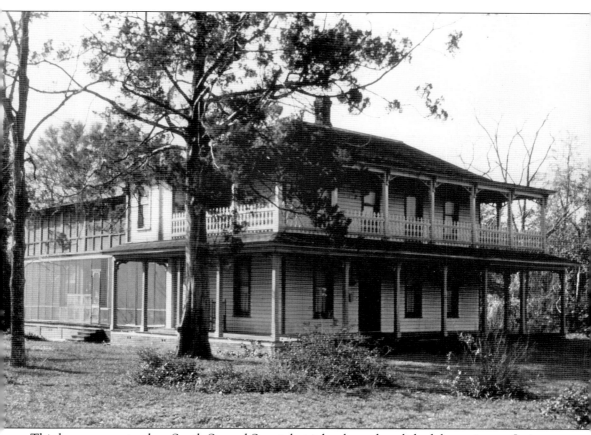

This house once stood on South Second Street, but it has been demolished due to its age. In its prime, it was the home of Percy W. Miles, owner of the P. W. Miles Lumber Company, and his wife, Dora.

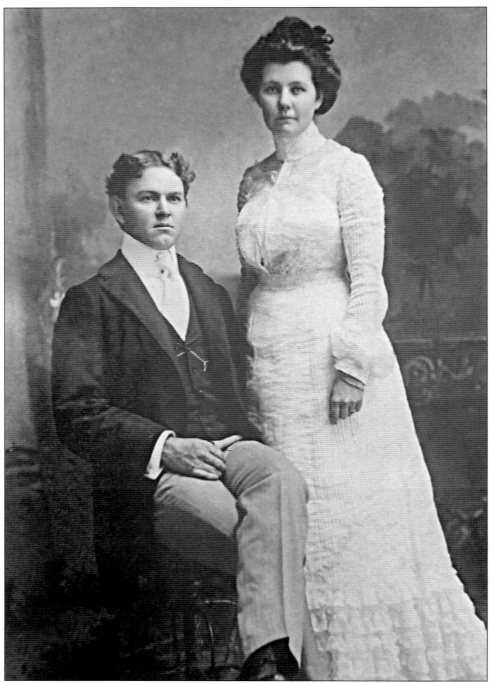

Harley Emmett Wickersham and his wife, Coralee, lived on Circle Drive. Coralee was the sister of Donald Stuart Gillis, a circuit court judge. The Wickershams restored a house in Grayton beach called Washaway House, which still stands, and renamed it Wickhaven. Other DeFuniak Springs residents had beach homes in Grayton Beach, including the owners of Beach, Rogers and Company. (Courtesy of Perry Correll.)

Eight
HOTELS

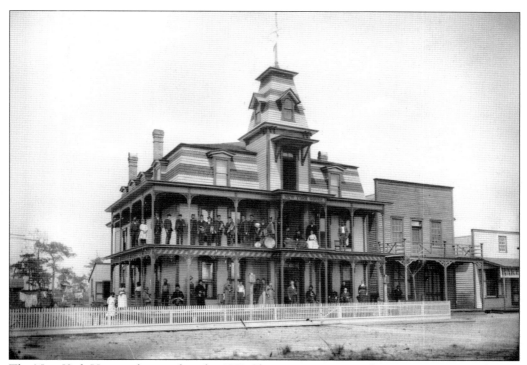

The New York House advertised in the 1893 Chautauqua program that is was open. "We keep a first-class hotel. Everything comfortable and home-like. For special rates by the month or season write J. C. Scott, DeFuniak, Fla." In the program, Scott was described as "so favorably known at New York Chautauqua." The hotel was destroyed in the 1898 fire on Baldwin Avenue.

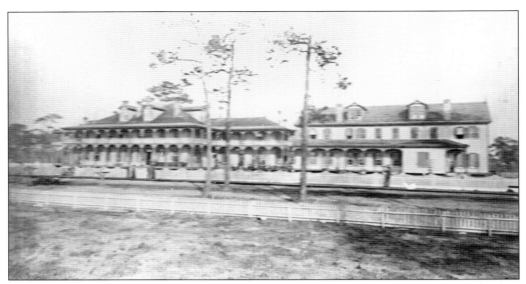

G. Willard Shear captured the Hotel Chautauqua in 1887. It was built in time for the first Florida Chautauqua Assembly in 1885 by Col. D. K. Hickey, who owned the Continental Hotel in Pensacola.

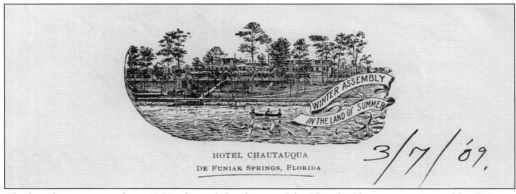

The hotel's stationery from 1909 adopted the theme of the Florida Chautauqua Assembly, "Winter Assembly in the Land of Summer." (Courtesy of Scott Clary.)

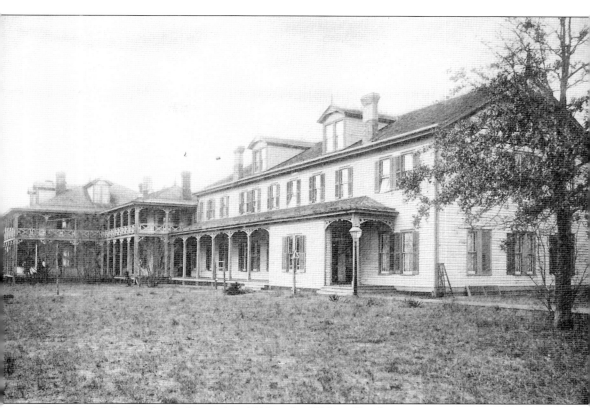
The name of the hotel was changed in 1912 to the Walton Hotel.

The Walton Hotel used this postcard as an advertisement. On the reverse was typed, "Summer rates are the same rates we have year around. The weekly rate for a single with private bath is $18.00 per. We hope that we may be able to serve you in the future." By the early 1920s, the name had once again been changed to the New Walton Hotel, and the Florida Chautauqua had been forgotten in favor of the Old Spanish Trail. (Courtesy of Scott Clary.)

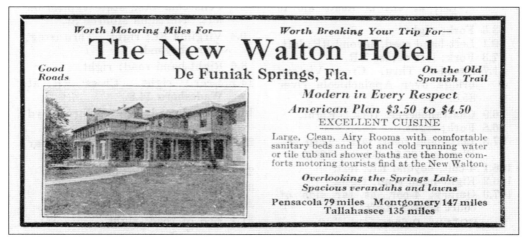

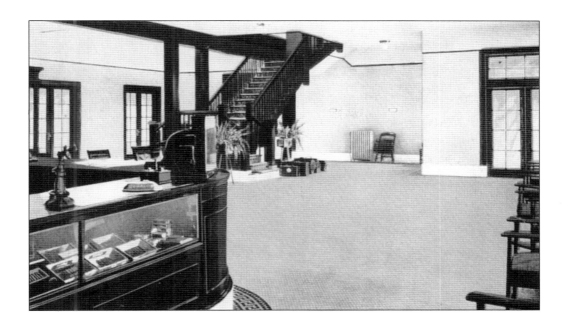

Photographs of the New Walton Hotel's lobby and dining room were used for postcards. George Orkney Waits was vice president and general manager of Henderson-Waits Lumber Company in nearby Caryville. In 1922, he wrote a love letter to his girlfriend, Virginia Mauley of DeFuniak Springs, while waiting for her to join him in the dining room of the New Walton. "I hate so bad to leave you this morning but of course I must go and look after my business and I know you want me to do that but I'll come back soon and see you some more." (Courtesy of Scott Clary.)

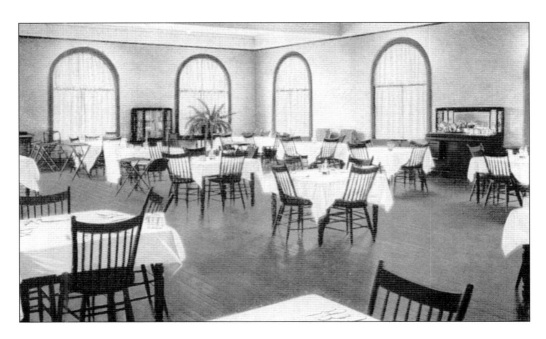

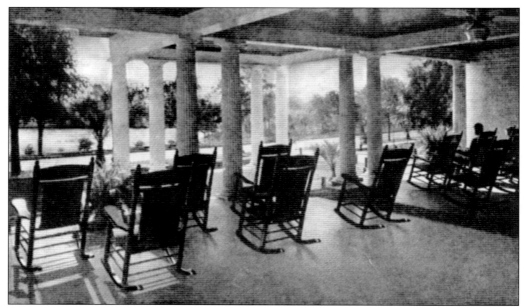
The porch of the New Walton Hotel had an unobstructed view of Lake DeFuniak. (Courtesy of Scott Clary.)

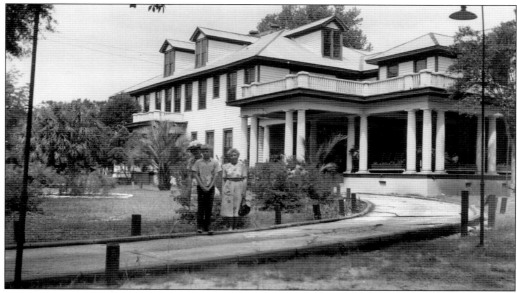
The drive leading up to the hotel is shown in the photograph above, which was taken in 1946. Pictured are Hanna Lulu Cox Patton (left), her sister Gertrude Cox Todd, and Gertrude's grandson, Wayne Wirth. The hotel was demolished in 1963. (Courtesy of Wayne Wirth.)

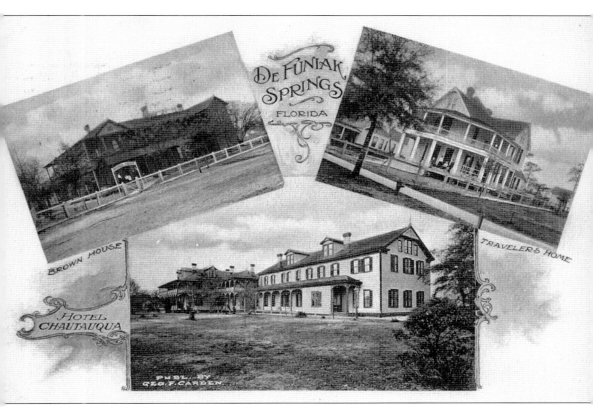

George F. Carden also produced promotional postcards for his photographic work. An article in the March 16, 1913, issue of the *Pensacola Journal* stated: "He is the grandson of Sir Robert Walter Carden of England, and great grandson of the famous John Walter Carden, who was at one time editor and owner of the London Times." (Courtesy of Scott Clary.)

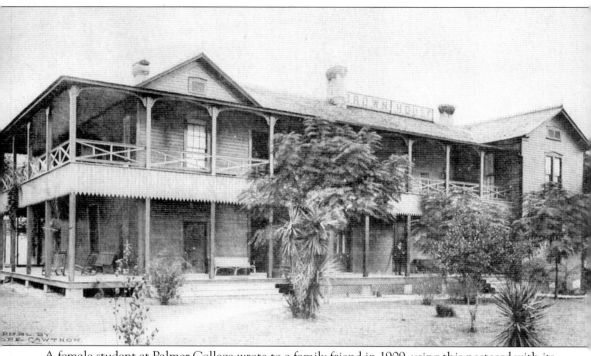
A female student at Palmer College wrote to a family friend in 1909, using this postcard with its photograph by T. Hope Cawthon, "The Brown House is where we staid until we came over to the Dormitory yesterday. The Dor's very nice. I think I will like it." (Courtesy of Scott Clary.)

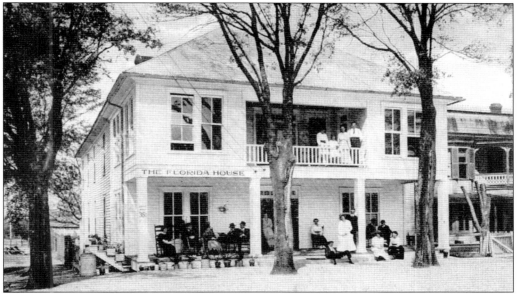

Camillus F. Hinesley was the proprietor of the Florida House from 1914 until 1928. It was located on Nelson Avenue at Eighth Street, across the avenue from Lightfoot's Drug Store and the Lake Hotel. A woman known as "Granny" worked there until 1937 and slept on a cot in a back room.

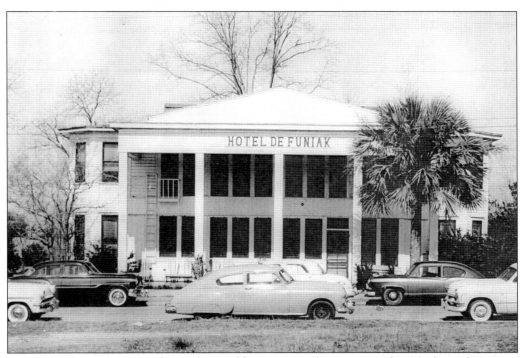

The original Hotel DeFuniak stood on Baldwin Avenue between Tenth and Eleventh Streets. In the 1890s, the hotel was known as the Martin House. It was demolished in 1961 or 1962. In recent years, another hotel adopted the Hotel DeFuniak name. It is located in the building that was once Lightfoot's Drug Store.

Masonic Lodge No. 170 was built at the corner of Eighth Street and Nelson Avenue in 1920. The lodge met upstairs and rented the downstairs to a furniture store. In the early 1930s, Stealie Preacher and his wife, Ella, converted the upstairs into the Lake Hotel. He maintained his law office downstairs, and she ran a dining room. In the 1940s, the building was sold to pharmacist Marshall James Lightfoot and served as both a drugstore and hotel (below) until his death in 1965. The Florida Hotel can be seen on the opposite side of Nelson Avenue. (Courtesy of Scott Clary.)

Nine
CHURCHES

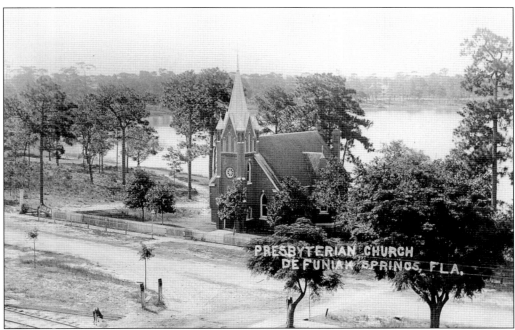

The First Presbyterian Church was established in November 1883. Its members first met in a modest log cabin on Nelson Avenue between Second and Third Streets. The second location was the office of Dr. Daniel L. Campbell, and the members met in at least two other locations before the original building (above) on Circle Drive was completed, probably by 1890. The church had encountered financial difficulties, so Frederick de Funiak provided the bricks for the building, and Maj. William Van Kirk paid for the labor by the brick masons.

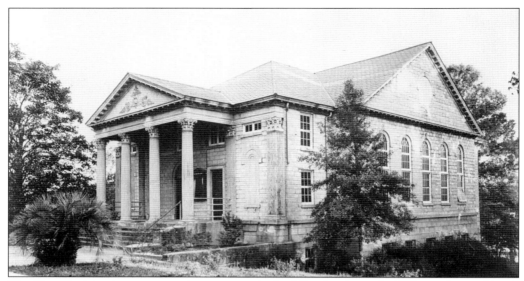

The First Presbyterian congregation outgrew the building by the early 1920s, and its red brick facade was demolished. The replacement building (above) was built in 1923 of petrilite, a concrete product manufactured locally, at a cost of $45,000. (Courtesy of Scott Clary.)

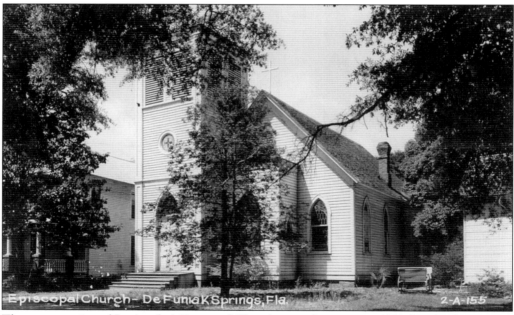

The congregation of St. Agatha's Episcopal Church started meeting in 1893, but the first service in the building was not held until Easter Sunday 1896. The church opened seasonally from 1896 until 1910 and was served by visiting clergy. Of all the early churches, it is the only one still in its original building and is home to the only pipe organ in Walton County. (Courtesy of Scott Clary.)

The Methodist Episcopal church, Northern Branch, was established in 1887. The first church building was on Circle Drive, just north of its current location. Around 1900, the Methodist Episcopal church, South, began meeting in DeFuniak Springs and built its church on Nelson Avenue. The Northern Branch's Circle Drive church burned down and, in 1901, was replaced by a large frame building (pictured here) at the corner of West Avenue. The two churches merged in 1907, used the Circle Drive building exclusively, and became known as the First Methodist Church. In 1967, it was decided that the building should be replaced by another structure with more room and functionality. The building was razed and replaced by the present brick structure. The Nelson Avenue building was used for various purposes until it was destroyed by a fire. (Courtesy of Scott Clary.)

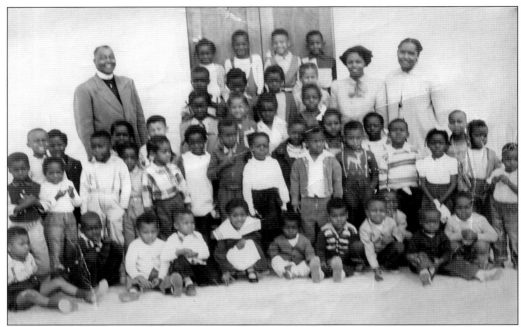

Bethel Presbyterian Church was established on Roosevelt Avenue in 1930 and was an offspring of Pleasant Grove Presbyterian Church in Euchee Valley. Its most notable contribution to the community was the establishment of a pre-kindergarten school and day care center under the direction of Rev. Joseph B. Rodgers (above) in 1952. The day care center predated Head Start programs and closed in 1965. (Courtesy of Annie Ruth Campbell.)

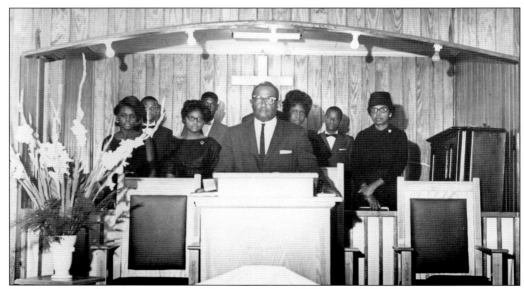

Rev. Lorgust A. Bayne was pastor of the church from 1961 until 1964. The choir behind him in this 1964 photograph is, from left to right, Deloris Fletcher, Bayne's son Jonathan and daughter Lydia, John W. Clayton, Sarah Fletcher, Norman Campbell, and Bayne's wife, Elsie E. Bayne. (Courtesy of Annie Ruth Campbell.)

Around 1944, the U.S. government procured land south of DeFuniak Springs for the Eglin Reservation. The families living on that land were forced to relocate, causing homes and churches to be abandoned. Southwide Baptist Church was organized in 1945 by Rev. Murdock Morrison and some 40 members of the former Alice Creek and New Home Baptist Churches. The land sale document above from 1956 references that Millard E. and Emma Gainey had previously conveyed "four acres more or less" to the trustees of the Southwide Baptist Church. The children below, attending baptism class in August 1953, are, from left to right, (first row) Carolyn Spence, James Brannon, Doug Ward, Donnie Brackins, and Frank Brannon; (second row) Geraldine Spence, Marie Gainey, Betty Griner, and Wyndol Shaw; (third row) Rogene Ward, Kathleen "Kit" Gandy, and Floyd Spence. (Both courtesy of Marie Gainey Hinson.)

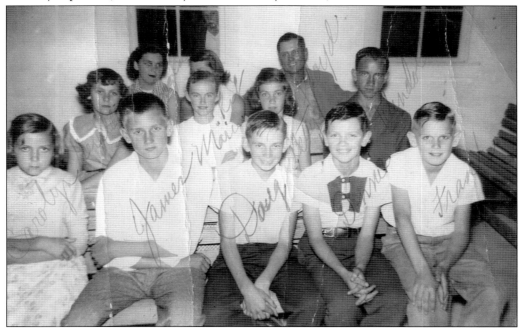

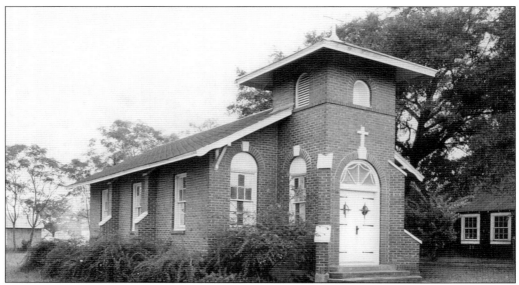

The members of St. Margaret of Scotland Roman Catholic Church began meeting in homes prior to 1920 and were served by visiting pastors. The church was in the Mobile (Alabama) Diocese when it received its first priest, Fr. Augusta Bayne. This building was constructed in 1931 on East Nelson Avenue and still stands directly across from the courthouse but is not in use. Another church building was dedicated in 1981 on Highway 331 North. (Courtesy of Scott Clary.)

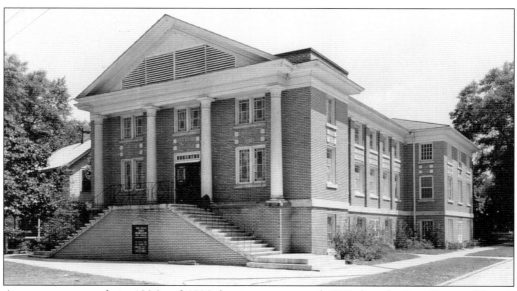

Attempts were made in 1886 and 1898, but it was not until 1902 that the First Baptist Church was organized. It met in two other locations until its first building was completed in 1903. That building was destroyed by fire in October 1926, and a new brick building (above) and educational center opened on Christmas Day 1927. (Courtesy of Scott Clary.)

Ten

COMMUNITY

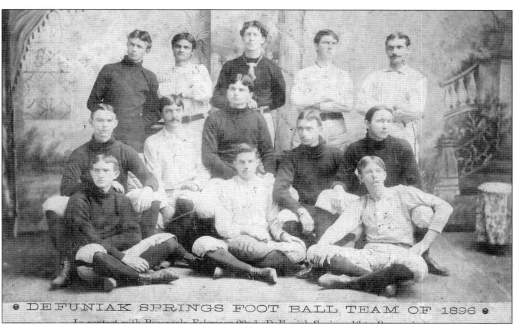

G. Willard Shear took this studio photograph of the 1896 DeFuniak Springs football team. Unfortunately, the history of this team and the names of its players remain a mystery, but it may have been the Florida State Normal School team. The team played Pensacola on February 22, 1896, and won with a score of 16-0.

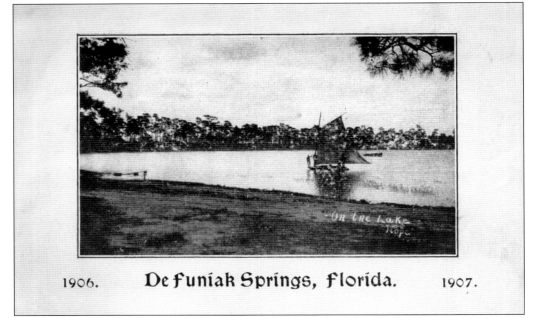

The Woman's Town Improvement Association produced a booklet promoting DeFuniak Springs. T. Hope Cawthon was vice-president of the association, and his photographs were used throughout to illustrate the text. (Courtesy of Scott Clary.)

Cawthon also produced an album of his postcards and books of his larger prints. The *DeFuniak Herald* reported in its November 13, 1913, edition that Cawthon had gone to Nashville, Tennessee, the previous week to marry Hattie Matlock, and he moved his photography business to Florala, Alabama.

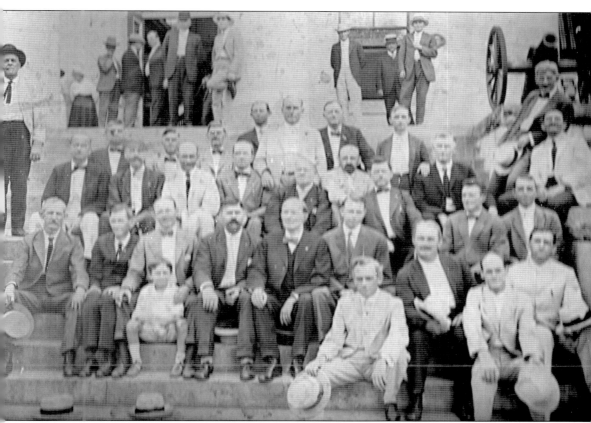

Sidney Johnston Catts was a Baptist minister who moved to DeFuniak Springs from Alabama and sold insurance. He was the first Florida gubernatorial candidate to campaign using an automobile, and the first to use automobiles in his inaugural parade. Catts served as governor from 1917 until 1921, during which time he initiated reforms in the prison system and for the treatment of the mentally ill, ratified the 18th amendment to the federal constitution concerning prohibition, and endorsed women's suffrage. In the photograph above titled "Old Catts and the Kittens or the Royal Guard of the House 1917," Catts is in the middle of the seated group; a man in a light suit is standing behind him. Walton County's representative, Angus L. Anderson of DeFuniak Springs, is the last man seated on the right in the row behind Catts, with a man's hand on his right shoulder.

STATE OF FLORIDA
EXECUTIVE CHAMBER
TALLAHASSEE
May 13th., 1918.

SIDNEY J. CATTS
GOVERNOR
J. S. BLITCH
SECRETARY

Miss Christian McDonald,
Argyle, Fla.
Dear Christian:

 I came in Saturday evening tired to death and saw your postal card on my desk telling me of the death of your father and wrote you only a few lines with my own hand to let you know how much I sympathized with you and the entire family in this your season of great trouble, for a person never has any two friends on this earth who are so close to them as their mother and father and I think that you had one of the best fathers I ever knew; a man who strictly attended to his own business and let everybody else alone and whose faith was in God, and I certainly am sorry to know that we will see him no more in this world. I will miss him and his genteel, kind ways and I am sure that your mother and all the children are heart broken over his leave taking for a better world.

 I was so tired that when I went home Saturday night I did not eat any supper but fell asleep and knew nothing until next morning. So I hardly know what I wrote you but I desire to express in this letter my earnest and sincere appreciation of the fact that your father was my friend and that I was his and that as long as we had known each other we had the highest and best opinions of each other. I sincerely hope and trust that the promises made by our Father in His Wholy Book will comfort and sustain you, your loving mother and sisters in this great time of bereavement and distress and if I can be of any service to you or any of the others do not hesitate to call on me and I will do everything in my power to show my friendship.

 Hoping that each and every one of you are well and that God's greatest blessings will rest upon you all, I am

Yours sincerely,

[signature]

Governor.

C-G

Governor Catts had his detractors. He was constantly at odds with those who controlled the state legislature, and many of his ideas were considered radical. The letter above, dated May 13, 1918, shows another side of Catts, perhaps the side voters saw in 1916 and certainly the side his parishioners at First Baptist Church knew. It reads, in part, "I came in Saturday evening tired to death and saw your postal card on my desk telling me of the death of your father and wrote you only a few lines with my own hand to let you know how much I sympathized with you and the entire family in this your season of great trouble, for a person never has any two friends on this earth who are so close to them as their mother and father and I think that you had one of the best fathers I ever knew . . . and I certainly am sorry to know that we will see him no more in this world."

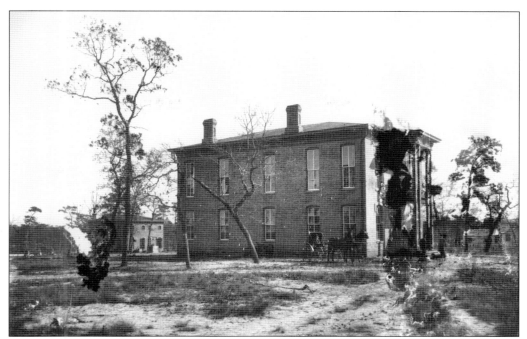

In 1871, a monument was commissioned to honor Walton County's Confederate dead and was the first of its kind in Florida. It first stood at the Valley Church and then was moved to the Eucheeanna courthouse until the county seat was moved to DeFuniak Springs. In 1886, the first courthouse in DeFuniak Springs was built (pictured above in Shear's damaged glass plate), and the monument soon followed.

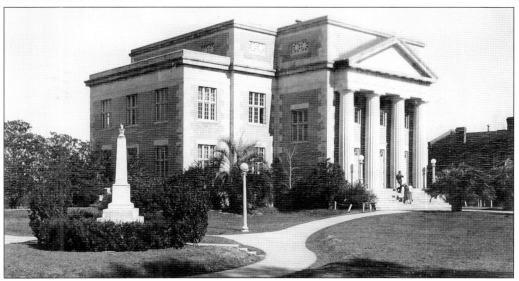

This Walton County courthouse was built in 1926, and the Confederate Monument, seen in the left forefront, was moved to its current location about that time. The apex of the monument was a clenched fist with an index finger pointing skyward, but the fist is no longer there. The old courthouse can be seen in the distance on the right in this 1940s photograph. (Courtesy of Scott Clary.)

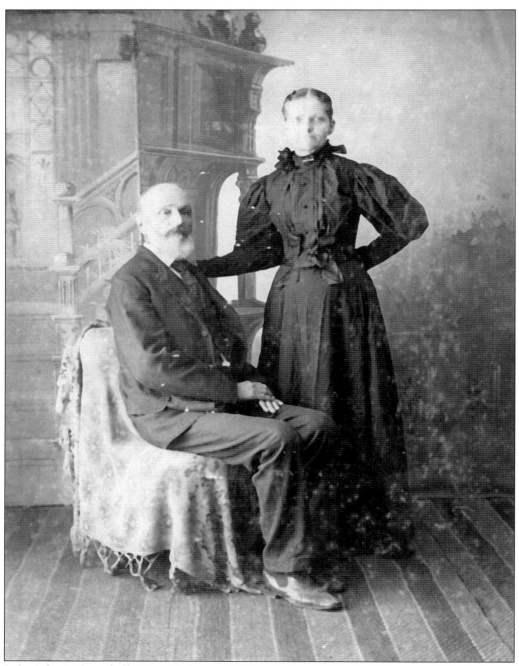

Judge John L. Campbell, pictured above with his wife Annie Edge, had the unusual distinction of being both a sheriff and a judge. He served as the sheriff of Walton County from 1865 until 1867 and was the first Walton County judge, serving from 1887 until 1889 and again from 1893 until 1896. Some of his successors were Judge S. P. Darby (1889–1893), Judge D. G. McLeod (1897–1909), Judge W. E. Parrish (1909–1916), Judge A. R. Campbell (1916–1929), Judge J. W. Mathison (1929–1933), and Judge D. N. Trotman (1933–1934). (Courtesy of William Steadley-Campbell.)

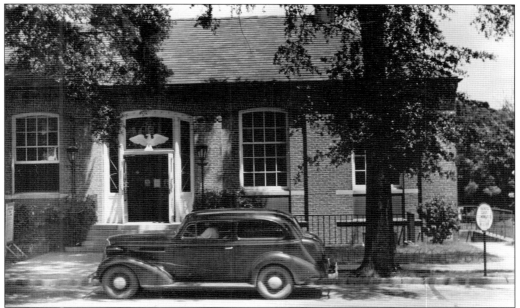

The U.S. Post Office has changed locations many times over the years. It was once located in this building on Nelson Avenue, on a corner west of the Walton County Courthouse. The building is still in use today as a title company office. The library, shown below around 1900, was completed in 1887 to provide resources for Chautauqua. The building was originally one room, but additions were added in 1893, 1921, and 1984. Volunteers served the public until 1902, when a full-time librarian, Alice Fellows, was hired to care for the 2,000 books then in the collection. The library is the oldest structure in Florida built as a library and still serving that purpose. It serves as the home of the Kenneth Bruce armor collection, some of which dates back to the Crusades.

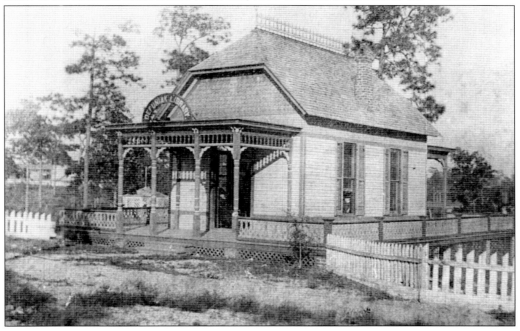

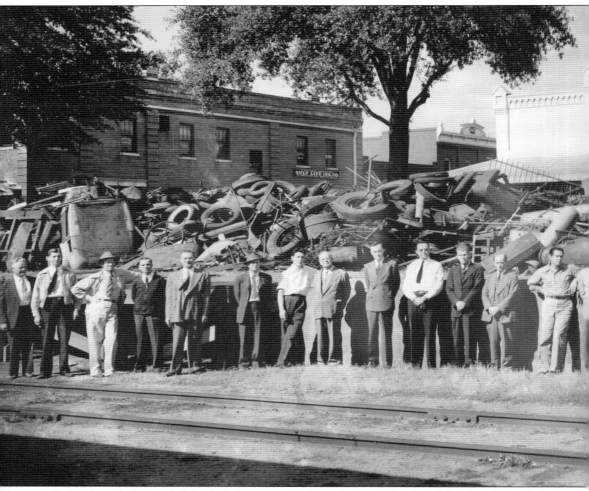

In 1942 or 1943, some of the businessmen of DeFuniak Springs gathered for this photograph in front of a large pile of scrap metal and tires collected for the war effort. David H. Bludworth, whose father was a prisoner of war during World War II, was a young child at the time who reports, "They sacrificed when asked, turning off unneeded lights, sending in copper products, steel and other scrap for use in the war effort. Seeing scrap gatherers was not uncommon as it not

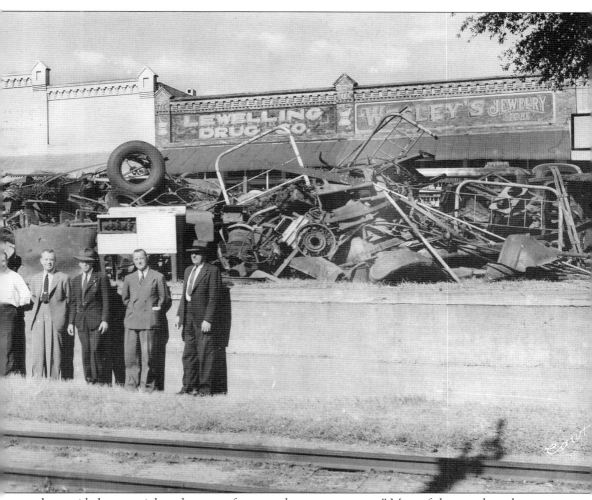

only provided some a job and source of revenue but was necessary." Most of the men have been identified. From left to right are unidentified, Guy Davis, Aubrey McDonald, Adrian Rivard, ? Apostle, unidentified, William Olin Campbell Jr., Robert E. Lee McCaskill, Harold Gillis, Obie Gatlin, Angus Graham Campbell Jr., Aaron Wohl, Howard Storrs, Ralph Campbell, Thomas Lathinghouse, Melville Jennings, Archie Neal Anderson, Tom Beasley, and Rev. Call Leach.

BIBLIOGRAPHY

DeBolt, Dean "The Florida Chautauqua." *F.E.H. Forum: The Magazine of the Florida Endowment for the Humanities*, Vol. 13, No. 3, Fall 1990.

Gills, Harold. "Chautauqua Times." *The Florida Chautauqua*. DeFuniak Springs: The Chautauqua Festival, 1985.

Herr, Kincaid A. *The Louisville and Nashville Railroad, 1850–1963*. Lexington: University Press of Kentucky, 2000.

Historic Property Associates. *Historic Properties Survey of the City of DeFuniak Springs, Florida: A Study of the Historic Architectural Resources of DeFuniak Springs and Recommendations for Their Preservation*. St. Augustine, FL: Historic Property Associates, 1990.

McKinnon, John L. *History of Walton County*. Gainesville, FL: Palmetto Books, 1968.

Miller, Clyde E. "A Story of Early DeFuniak Springs," a series of 15 articles. *DeFuniak Springs Herald-Breeze*, 1977.

Moore, James E. *Walton Wanderings: A Swing and a Miss at History*. Valparaiso, FL: Bayou Printing, 1996.

Reardon, Anna. Various articles, 1956–1982.

Walton County Heritage Book Committee. *The Heritage of Walton County, Florida*. Clanton, AL: Heritage Publishing, 2006.

Woodward, David. "The L&N and De Funiak Springs." *The Dixie Line*. Louisville: L&N Railroad Historical Society, 1991.

INDEX

Abernethy, Bruce, 31
Abernethy, George H., 31
Anderson, Angus L., 33, 119
Anderson, Archie Neal, 124
Anderson, John Roderick, 33
Bayne, Augusta, 116
Bayne, Lorgust A., 113
Bruce, Kenneth, 123
Bruce, Malcolm, 86
Bruce, Wallace, 7, 23, 28–31, 86, 87
Campbell, Angus Graham Jr., 124
Campbell, Daniel Douglass, 68
Campbell, Daniel L., 68, 111
Campbell, John L., 122
Campbell, Norman, 113
Campbell, Ralph, 124
Campbell, Sarah Jeanette, 68
Campbell, Theophilus Preston, 45
Campbell, William Olin Jr., 124
Carden, George F., 31, 94, 107
Catts, Sidney Johnston, 33, 95, 119, 120
Cawthon, Fannie Lou, 64, 65
Cawthon, John Crenshaw Burruss, 65, 72, 97
Cawthon, Lewis Hutchison, 64
Cawthon, Mary Lou, 97
Cawthon, Murray A., 64, 65, 97
Cawthon, Thomas Hope Wesley, 2, 26, 34, 38, 48, 56, 66, 67, 82, 90, 97, 98, 108, 118
Cawthon, Walter Clayton, 97
Cawthon, William Lee, 65, 66, 97
Chipley, William Dudley, 7, 85

Cleveland, Larkin, 62, 63
de Funiak, Frederick, 14, 111
Gillet, August H., 22, 25
Gillis, Donald Stuart, 100
Gillis, Harold, 66, 67, 124
Gillis, Stuart Knox, 96
Harbeson, W. B., 49
Henry, George P., 15
Lightfoot, Marshall James, 96, 110
McCaskill, John Jett, 29, 59
McCaskill, Robert E. L., 59, 60, 124
McKinnon, John L., 8, 22, 126
McLean, Charles C., 22
McLean, James A., 92
McLeod, D. G., 122
McLeod, D. L., 67
Murray, Charles, 73
Paul, George R., 77, 78
Preacher, Stealie M., 40, 110
Rogers, Henry Jewett, 50, 52
Rogers, William, 50
Saunders, Maude, 40
Shear, G. Willard, 2, 7, 23, 24, 47, 49, 87–89, 102, 117, 121
Storrs, Howard, 124
Storrs, Royal W., 62, 88
Thomas, Hiram W., 35
Van Kirk, William J., 7, 85, 89, 111
Walden, Talmer, 80, 81
Wickersham, Harley Emmett, 100
Wright, Thomas T., 7, 94

Across America, People are Discovering Something Wonderful. *Their Heritage.*

Arcadia Publishing is the leading local history publisher in the United States. With more than 4,000 titles in print and hundreds of new titles released every year, Arcadia has extensive specialized experience chronicling the history of communities and celebrating America's hidden stories, bringing to life the people, places, and events from the past. To discover the history of other communities across the nation, please visit:

www.arcadiapublishing.com

Customized search tools allow you to find regional history books about the town where you grew up, the cities where your friends and family live, the town where your parents met, or even that retirement spot you've been dreaming about.